THE QUICKEST WAY
TO DRAW WELL

Frederic Taubes is not only one of the best-known American artists today, but is also the author of many books, including *The Quickest Way to Paint Well, Better Frames for Your Pictures,* and *A Guide to Traditional and Modern Painting Methods.* He teaches throughout the country, has written a column for *American Artist* magazine for many years, and is widely exhibited in galleries, museums, and private collections.

The Quickest Way to

DRAW WELL

By

FREDERIC TAUBES

 Penguin Books

Penguin Books Ltd, Harmondsworth,
Middlesex, England
Penguin Books, 625 Madison Avenue,
New York, New York 10022, U.S.A.
Penguin Books Australia Ltd, Ringwood,
Victoria, Australia
Penguin Books Canada Limited, 2801 John Street,
Markham, Ontario, Canada L3R 1B4
Penguin Books (N.Z.) Ltd, 182–190 Wairau Road,
Auckland 10, New Zealand

First published in the United States of America
by The Viking Press 1958
Viking Compass Edition published 1975
Reprinted 1975
Published in Penguin Books 1977
Reprinted 1978, 1979, 1981

LIBRARY OF CONGRESS CATALOGING IN PUBLICATION DATA
Taubes, Frederic, 1900–
The quickest way to draw well.
(A Penguin handbook)
1. Drawing–Instruction. I. Title.
[NC650.T3 1977] 741.2 77-1440
ISBN 0 14 046.275 9

Printed in the United States of America by
The Murray Printing Company, Westford, Massachusetts
Set in Linotype Caledonia

Contents

PART I

Materials and Methods

There are many techniques in drawing and also many materials from which to choose. We have come a long way since the days when men drew crudely on the walls of caves; we have come a long way too, for that matter, since the time of the Renaissance in Italy —if not in artistry, then certainly in technical aids. Mass production and modern methods of distribution have also brought the best of materials within range of everyone.

Drawing in itself is an extremely varied and rewarding occupation. Not only that; drawing represents the gateway to painting. Without some knowledge of drawing, no one can expect to be proficient with a brush.

This book, then, is as much for the beginner in oil painting as it is for the graphic artist. While learning to draw with pencil or pen, the student is preparing himself to draw later with a brush on canvas. We must not forget, either, that the preliminary work for an oil painting is done on paper. Pencil notes and sketches aid the artist in developing his theme and composition before he starts out to paint.

DRAWING MATERIALS

Pencil. This, of course, is the most common of all drawing instruments. Pencils can be had with leads ranging from very hard to very soft. For most purposes a selection within the range of medium hard (HB) to medium soft (6B) will suffice. Very hard

7

leads produce lines that are too light, and extra-soft leads are likely to smear. On occasion, however, there may be uses for these, too. Markings of the pencils recommended for general use are reproduced in Fig. 1 (*A*). An entire drawing done in a medium-soft pencil (which will be your best tool) is shown in Fig. 2.

The effect achieved by drawing with the point of the lead is very different from that done with the edge—that is, when the pencil is held flat between thumb and forefinger against the paper. The one permits sharp and clear delineations; the other technique is used for broad, sweeping strokes and shading. Try your pencils each way to get the feel of them.

It is necessary always to keep pencil points sharp. Pencil sharpeners are seldom used by professionals. A knife or razor blade is best for setting a long, sharp point and should be kept by your side all the time you are working. You may also find a block of very fine sandpaper handy for rubbing a pencil point to a needlelike sharpness if required.

Charcoal. Three types of charcoal are available: vine charcoal, synthetic charcoal, and charcoal sold in pencil form. The last two are made of carbon and leave marks of deepest black that cannot be as easily erased as those made by vine charcoal.

Personally, I find vine charcoal best for general use. The effects of vine charcoal are seen in the practice strokes in Fig. 1 (*B*). Synthetic and pencil charcoal were used for the man on horseback on page 6. This drawing was done on Ingres paper, which has an attractive medium-rough finish.

Crayon. Crayons come in many colors and types. For drawing purposes, stick crayons sold under the trade name of Conté are most often used in black, sanguine (red), and bistre (brown or sepia). They are used in the same manner as charcoal or soft pencil and produce quite similar effects. I recommend that these crayons form part of every artist's standard equipment.

By trying out the effects of different pencils and of charcoal and crayon you will soon establish your preferences. Very often more than one of these mediums can be used effectively in the same drawing.

Pen and ink. This is harder to handle, if for no other reason than the fact that erasures are difficult. Most beginners will do well to start out with pencil or crayon and then progress to pen and ink. But experiments should not be delayed too long. A relatively

8

early training in the use of all materials is recommended. This way the student will gain a knowledge of the full range of materials and the numerous effects at his disposal. Which medium is more to your liking can be discovered only through experimentation.

Besides the old-fashioned penholder (and bottle of ink), I strongly recommend a special India ink fountain pen. This can now be obtained for around three dollars. The draftsman should not limit himself to one type of pen point. Several points of different thickness will be useful.

In addition, a felt-point pen, discussed below, will be useful as secondary equipment in the studio, and there is also a special ball-point pen which many artists find extremely useful, particularly while traveling.

The effects of various pen points are seen in the practice strokes in Fig. 1 (C) and (F). It is a good procedure to make many practice sketches like this before tackling any specific drawing. By getting the feel of your tools first you can start to draw with greater confidence and ease.

Felt-point pen. Referred to above, this fairly new type of pen is sold under various trade names (such as Flomaster). Although the felt point is thick in shape, it can produce surprisingly delicate markings too. Depending on the amount of ink the felt-point pen contains, tones of lightest gray as well as deepest black can be obtained. The versatility of the pen makes it possible to simulate the effects of brush and ink, pencil, or soft crayon, depending on the nature of the paper and the kind of technique employed. A few practice strokes are shown in Fig. 1 (F) and a complete drawing made with this pen is illustrated in Fig. 4. This was done on a thick sheet of medium-rough drawing paper.

Brush and ink. Calligraphic lines can be most easily achieved with a round water-color sable brush. For most purposes a No. 2 brush will be sufficient. The fine point of a No. 2 brush can produce very thin lines, as well as lines of considerable thickness. This is demonstrated in Fig. 1 (D). In Fig. 3 a pen point was used in combination with the brush. This device can give very satisfactory contrasts to the tone of a drawing.

It is also effective when a brush is used in a background area or for shading, while a pen is employed for the sharp outlines or accents. Naturally, to avoid smudging or running, use the pen over a brushed background area only after it has properly dried. Com-

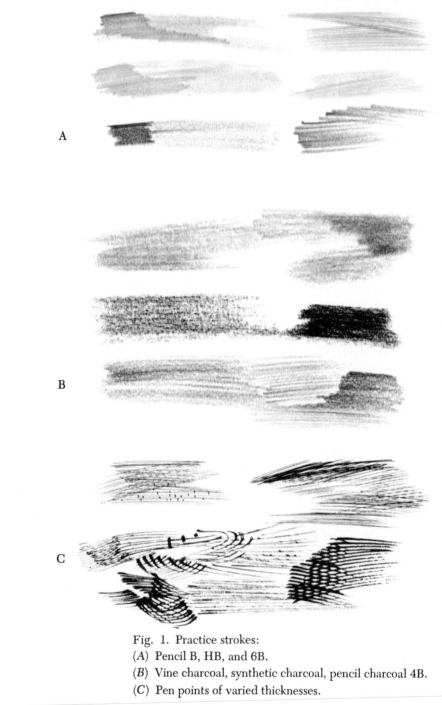

Fig. 1. Practice strokes:
(A) Pencil B, HB, and 6B.
(B) Vine charcoal, synthetic charcoal, pencil charcoal 4B.
(C) Pen points of varied thicknesses.

A

B

C

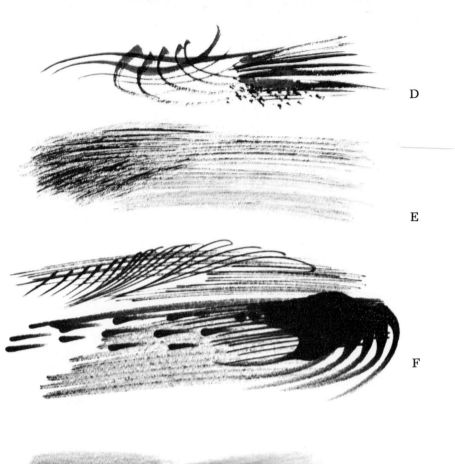

D

E

F

G

(D) Round sable brush.
(E) Dry brush.
(F) Felt-point pen.
(G) Effects made by pencil and stump.

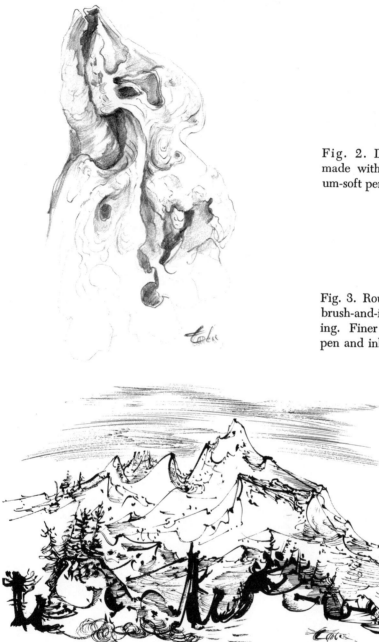

Fig. 2. Drawing made with a medium-soft pencil.

Fig. 3. Round sable brush-and-ink drawing. Finer lines are pen and ink.

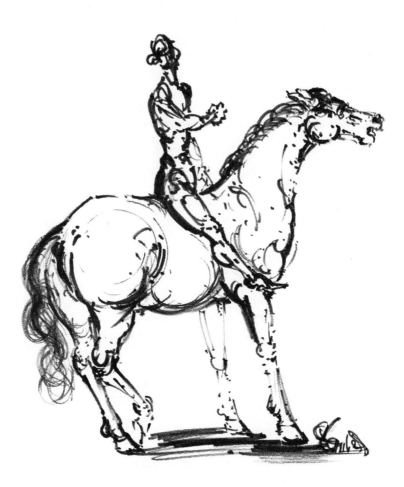

Fig. 4. Felt-point pen drawing.

binations of color and tone are also possible, and crayon can be used in conjunction with a pencil or pen. Some shading might be done in bistre, while outlines and perhaps additional shading of the main objects can be done in black.

Fig. 1 (*E*) shows the marks of a bristle brush. This type of brush is used for a dry-brush technique. For the rather scrubby appearance of the brush marks, the bristles are moistened only slightly with ink. In this way you can obtain rough textures which are very

13

different from the smooth, wet strokes of a soft water-color brush or the markings of a pen. Old brushes can be used for this purpose; in fact, many half-worn-out or scrubby-looking brushes will produce interesting rough textures. These can be used in certain areas of a drawing, such as grounds or woodland foliage.

Inks. When I recommended the use of India ink for pen drawing, I was thinking of the black ink. At times, however, a brown (sepia or bistre) India ink may be preferable, or you may wish to use brown in combination with the black. Brown gives a softer and warmer effect.

Common black writing ink can also be used for drawing purposes but the results will not be so rich, nor will they appear so professional-looking. I suggest that writing ink be used only for sketching and then only occasionally.

Erasers and erasing. For pencil, art gum and kneaded erasers are used; for charcoal, kneaded erasers are used almost exclusively. A special, harder type of eraser is made for removing ink marks, a process recommended only in emergencies.

No matter what medium you are working in, as a general practice it is better not to erase more than you can possibly help. It is better to start a drawing afresh than constantly to resort to the use of an eraser. While you are practicing or making preliminary sketches, erasing is more in order; but when you are working on a finished drawing, the marks of an eraser can ruin the artistic effect.

You may find encouragement in the fact that master Chinese draftsmen often made dozens and dozens of drawings of the same subject before they arrived at the perfection of line they were striving for. This method has an additional reward in that by constantly redoing the same subject, not only do you get to know it intimately but your skill increases with the practice—more so than by erasing and patching up.

Tortillon stump. This instrument can be used in conjunction with pencil, charcoal, or crayon drawing only. A stump is made of soft paper, one end of which tapers to a point like the end of a sharpened pencil. The use of this stump is limited to rubbing down soft pencil, charcoal, or crayon marks to achieve soft tonal transitions. The technique is referred to as pencil and stump and the effect is shown in Fig. 1 (G). The result is neater than that of using a finger, though smudging with one's finger is also feasible where very soft effects are desired in larger areas. Try out both on a practice sheet of paper and examine the results.

14

PAPER

For most purposes any good quality medium-grain and me-
dium- to heavy-weight drawing paper is suitable. Papers come in
many different qualities, colors, thicknesses, and textures. Apart
from quality, which is of paramount importance for the appearance
of a drawing, the kind of paper you buy will be determined by the
drawing tool you plan to use. Any shade of white paper is recom-
mended; other colors may be suitable for certain effects.

Pencil will work well on slick (smooth finish) drawing paper
as well as on a medium-rough grain. Avoid shiny (gloss finish)
paper. Actually this type of paper is not sold as a drawing paper,
though it may be stocked in some art material stores.

For vine charcoal, a medium-rough drawing paper is the most
suitable, while for synthetic or pencil charcoal a slightly smoother
surface tends to be more agreeable.

Pen and ink requires a rather smooth or a slightly rough-grain
paper. On very rough-tooth drawing papers pen strokes cannot be
manipulated successfully. If used at all, such papers are best for
crayon where special grainy lithographic-type effects are desired.

Felt-point pen and dry-brush techniques look good on nearly
any paper, though felt-point renderings will vary from smooth to a
more granular effect according to the degree of roughness (or tooth)
of the paper.

Descriptions are, however, but a poor substitute for practice
on the papers themselves. The best method as a start is to buy
sheets or pads of paper varying from the smoothest to the roughest
and use one sheet of each as a test for each of the drawing tools
you have assembled. Then, with first-hand knowledge gained from
practice, you will stock up on the type of paper that suits your pur-
poses best.

One final word. Avoid using very thin or cheap quality papers
except for rough sketches. These papers tear easily, yellow more
quickly with age, and lack the quality that a good drawing deserves.

Tracing paper. The ordinary tracing paper sold in pad form or
in rolls is an excellent material for preliminary sketching as well as for
tracing. The paper is cheaper and the hard surface will not roughen
when erasures are made.

Quite often you may wish to trace a sketch to a more substantial
paper for a final drawing, and for this the thin paper is indispen-
sable. To make a tracing, a sheet of the tracing paper is thickly

A

B

C

D

E

rubbed on one side with crayon, or lightly with charcoal, then inserted (penciled side down) between the preliminary sketch and the paper to which the drawing is to be transferred. The outline of the drawing is then gone over with the sharp end of a brush handle or with a well-sharpened pencil. Ready-made, so-called graphite transfer paper can be obtained in artists' material stores.

THE NATURE OF LINES AND TONES

Drawings are made up of lines—all conceivable types of lines. They may be thin or thick, straight or curving, continuous or broken; and any of these may be airily spaced or densely grouped on the paper. Shading may be achieved by crosshatching, by parallel lines, or by more or less solid areas of pencil or pen marks. The nature of these marks and the total effect of their juxtaposition will establish both the style and the tone of a drawing.

In general terms, the use of fine lines will give a feeling of lightness or space to a drawing, and heavy lines drama and weight. Curving lines are graceful, straight lines are more forceful, jagged lines are restless, and long, sweeping lines suggest movement or growth.

A pencil drawing made up of unbroken lines (or outlines) is shown in Fig. 6. The effect is both light and placid. Broken lines, to give a staccato effect, were used in the felt-point line drawing in Fig. 4. A different and more sketchy use of broken lines is shown in Fig. 7. Another technique—a mass of fine lines—gives a quite different impression in Fig. 8.

Lines can possess or suggest shades ranging from light gray to the darkest black, depending on the nature of the material used, the pressure of the strokes, and their density—that is, the employment of more or of less white area around them. The amount of white space left around a pencil stroke can often create the illusion of greater lightness or darkness than the stroke actually possesses. For

Opposite: Fig. 5. Effects of drawing material on various papers: (A) Charcoal on Ingres paper. (B) Pencil on smooth and rough surfaces. (C) Pen and ink on smooth and rough surfaces. (D) Dry brush on smooth and rough surfaces. (E) Felt point on smooth and rough surfaces.

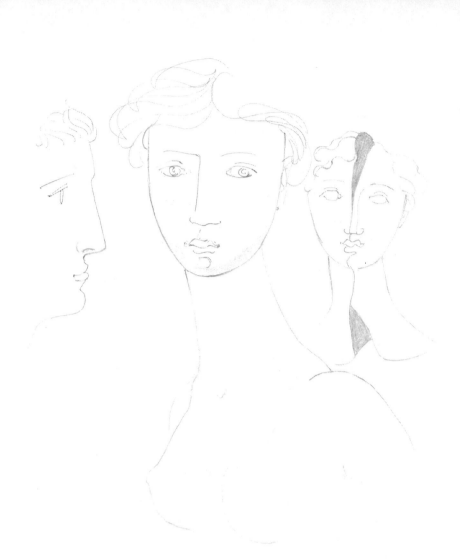

Fig. 6. Pencil drawing in unbroken lines.

Opposite: Fig. 7. Pen-and-ink drawing in broken-line technique.

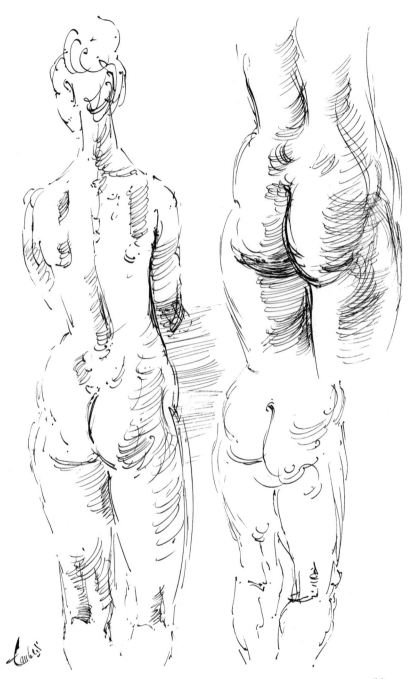

19

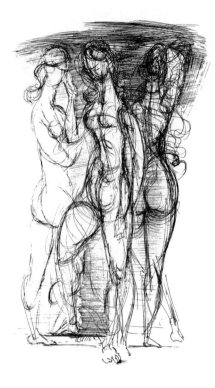

Fig. 8. Line drawing.

instance, a network of very fine ink lines (such as used in shading) can suggest a gray tone; a very heavy stroke of pencil against a large expanse of white can appear more black than gray.

FLAT AND THREE-DIMENSIONAL DRAWING

Drawing can indicate only the contours or outlines of an object. A contour drawing appears flat; that is, it possesses width and height only—the depth, not shown graphically, is left for the viewer to fill in with his imagination.

Flat, or so-called linear or line drawings, are demonstrated in Figs. 4, 6, and 8.

An object can also be drawn as a solid form—that is, one possessing bulk, which in turn creates an illusion of depth. The effect is achieved by the use of light and shade (*chiaroscuro*), as shown in Fig. 9. As we see, this drawing shows the depth, thus making the object appear three dimensional as expanded in nature.

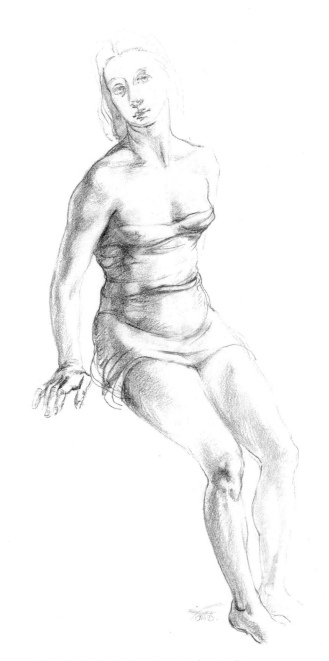

Fig. 9. Realistic drawing in classic chiaroscuro.

Although drawing in chiaroscuro is, as a rule, classic or realistic (light and shade relations following natural forms), chiaroscuro can also be used in an abstract way. We shall discuss drawings that do not conform to realistic principles—in other words, abstract drawings—a little later.

REALISTIC DRAWING

When a drawing is "true to nature," it is labeled realistic or *naturalistic*. Both expressions have essentially the same meaning. The drawing of a seated model in Fig. 9 (done in medium-soft pencil) is an example of the realistic or naturalistic approach. The drawing might very loosely also be termed classic. Strictly speaking, *classic* means drawings (or paintings or sculptures) done in a realistic manner that conforms to the style established in the Italian Renaissance. A nearer approximation to the classic is shown later in the book in Fig. 26 (*A* and *B*).

MODERN DRAWING

A characteristic of most so-called modern drawings, as opposed to realistic or classic types, is distortion. Here forms are, to a greater or lesser degree, twisted out of their normal shape. The reason for such distortion is the desire for dramatization, or intensification of expression. In a "distorted" drawing the proportions are altered, that is, all deviations from the normal are exploited to produce a planned effect (see Fig. 11). The suggestion of human forms is merely incidental, or, let's say, of quite secondary importance to the over-all pattern. Drawings like this and the one shown in Fig. 12 are labeled *semiabstract* or *abstract*.

STYLIZED DRAWING

When the degree of distortion is slight, we may refer to the drawing as stylized (Fig. 10). A stylized drawing is nearly always conditioned by a prevailing fashion in art. However else you may term them, stylized drawings are not classic or completely realistic, nor need they be abstract. Perhaps the best example of what I mean is to be found in contemporary book illustration. Most illustrators today use a stylized technique.

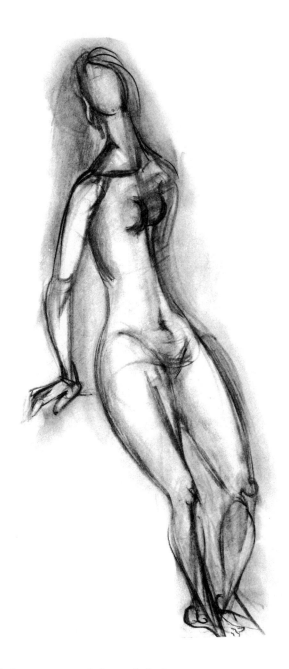

Fig. 10. Stylized drawing using light and shade.

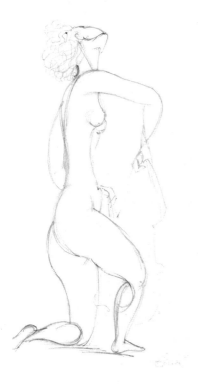

Fig. 11. Anatomical distortion.

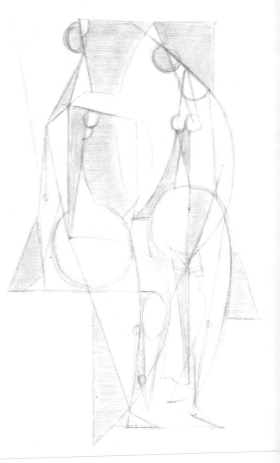

Fig. 12. Cubistic drawing.

DISTORTIONS AND SPONTANEITY IN DRAWING

While we are considering "distortions"—or, at any rate, departures from photographic realism—the element of spontaneity should also be taken into account.

When an artist depicts an object faithfully, the impulse of his hand must, of necessity, be disciplined. Drawing in a conventional or classic manner does not allow one to deviate from the prescribed course. On the other hand, when an artist draws freely, distortions are arrived at almost involuntarily and are often dictated by sudden, spontaneous whims. These, let's face it, can be either good or bad. However, with a skilled hand and a mind unfettered by convention, an artist can more easily capture the spirit of a subject and uninhibitedly render this effectively on paper. In the same way a caricaturist will catch the essential character of his sitter's face and more often than not make a more vivid likeness than a conventional portrait painter would. Classic drawings, though perfect in outward detail, are frequently not so much alive as caricatures. It is the quality of aliveness that contemporary artists strive for; and distortion, or spontaneous impressions of a pencil or brush, is one of the ways it is often achieved.

FLAT PATTERN

Drawings representing people, landscapes, or everyday objects are one thing; and pattern or design is another. Decorative pattern (as one might find on the borders of a tablecloth) is always bound to have a two-dimensional quality. It is seldom meant to be realistic. There is, however, an over-all pattern in every type of composition, but this is an entirely different matter which will be taken up later.

Any type of pattern can be symmetrical, in which case it will consist of equilaterally arranged parts, as in the abstract drawing reproduced in Fig. 13 (A). Or asymmetrical as in Fig. 13 (B).

GEOMETRIC FORMS

Almost any object can be reduced to simple geometric forms. Squares, triangles, circles, or ovals underlie most shapes we see in nature. In fact, many students find it easier to base their composition on an arrangement of geometric forms approximating the outlines of the objects they are drawing or painting.

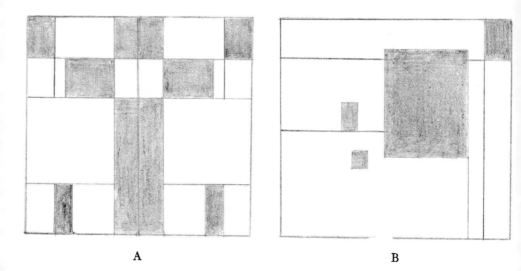

A B

Fig. 13. (A) Symmetric pattern. (B) Asymmetric pattern.

Naturally a house, animal, human form, vase of flowers, or mountain has different characteristics. Geometric forms, however, are neutral; that is, their shape is general, not particular. They fit within the characteristic outlines of any object. A square with a triangle on top will represent the outlines of a house; squares, triangles, and circles can also be used as a skeletal device in building up a human figure. For instance, a geometricized human figure (in the form of a manikin) is shown in Fig. 14. Fig. 15 also represents geometric forms, in the first place "disarranged" (A) and directly below it arranged into a composition (B).

ABSTRACT LINES

A line may serve not only to describe or to *delineate* an object but also to express a certain feeling or condition. Long parallel lines suggest a *static* or calm condition, and undulating lines evoke in our mind the sensation of rhythm. Oblique thrusts of lines express dynamic movement. Lastly, the impression of disorder is achieved by the use of a haphazard grouping of lines, each in discord with its neighbor. Examples are shown in Fig. 16.

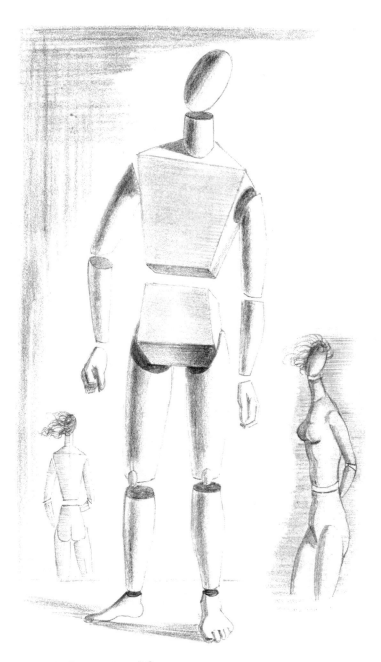

Fig. 14. Geometricized figures.

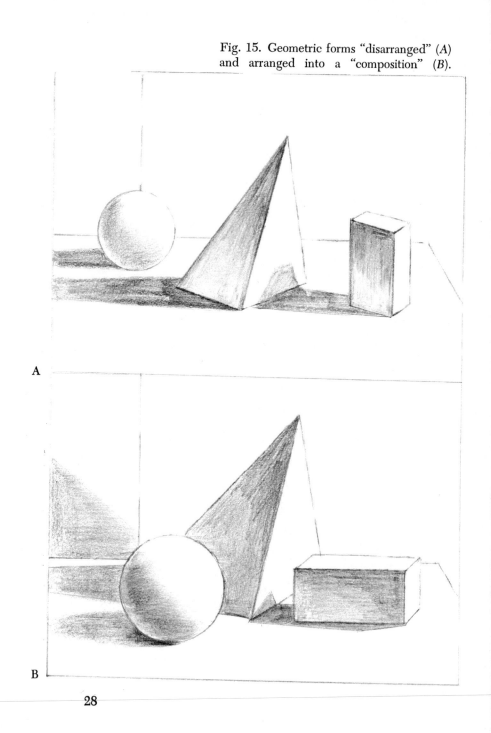

Fig. 15. Geometric forms "disarranged" (A) and arranged into a "composition" (B).

A

B

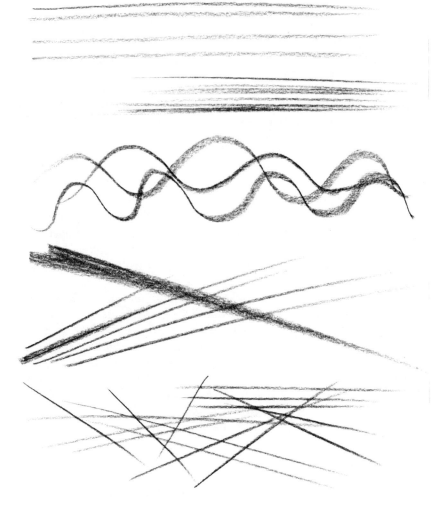

Fig. 16. Expressive lines. From top to bottom: Static; rhythmic; dynamic; disordered.

HARMONY AND DISCORD

From this discussion of lines we are naturally led to the subject of harmony and discord. This can apply to individual objects within a drawing or painting; it can also refer to a composition in its entirety. When it may be desirable to express discord if the subject matter demands it, the composition as a whole should never appear discordant. In other words, discordant lines expressing such phenomena as a hurricane or violent action should, nevertheless, be arranged in such a manner as to make the drawing itself appear harmonious and well composed.

COMPOSITION

Arrangement of forms can, as just stated, be disordered (Fig. 15 [A]) or orderly and harmonious (Fig. 15 [B]). What accounts for the feeling of harmony or balance, as we call it, is quite difficult to explain in words. Let us say that the presence of harmony is pleasurable to our eye, while lack of it produces a feeling of dissatisfaction and unrest.

Elements that lead to balance and harmony or the lack of it are demonstrated in the compositions in Fig. 17. In the first example (A) the main object, placed too close to the edge of the picture, produces an unbalanced effect. In example B the rigid, symmetrical grouping results in a stiff and unpleasing composition, while in C a harmonious arrangement of the same objects has been worked out. From these examples we see that a balanced composition does not necessarily require the identical placing of objects on either side of center. An arrangement of objects in asymmetrical balance, as they are more likely to be found in nature, is more agreeable and convincing.

Three objects can easily be arranged in balance and harmony. This is shown in Fig. 18 (A). Four objects, as in B, may also be balanced; but we find the composition far less interesting. Five objects are again a suitable number for an arrangement. See Fig. 18 (C).

Nature is always our best teacher; and if we study it we may see that, while everything in a landscape, for instance, may be well balanced, the individual objects themselves are not evenly grouped by twos, fours, or sixes.

A group of objects can always be selected to display a variety of

Fig. 17. Composition. In example *A* the main object is placed too close to the edge of the picture. In *B* the arrangement is too symmetrical. A harmonious composition is shown in the last example (*C*).

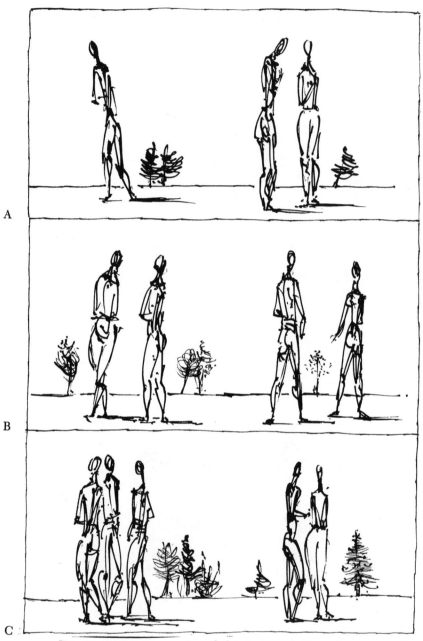

Fig. 18. An uneven number of objects (A and C) can be more easily grouped into a pleasing arrangement than an even number (B).

shapes, as in Fig. 19 (A). But when the same shape is repeated many times over, the result is monotonous (Fig. 19 [B]). Therefore, besides arranging our composition so that it has an asymmetrical balance, we should also introduce contrasting forms.

CENTER OF INTEREST

One further thing to remember when composing a picture: there should be a center of interest, or focal point. That is, there must be one object or a grouping of objects or else a mass of line to which the eye is continually drawn. This need not be exactly in the center but it should be toward the center of a composition.

Fig. 19. Objects possessing a variety of shapes can form an interesting arrangement (A), while a number of objects of the same shape (B) make a monotonous composition.

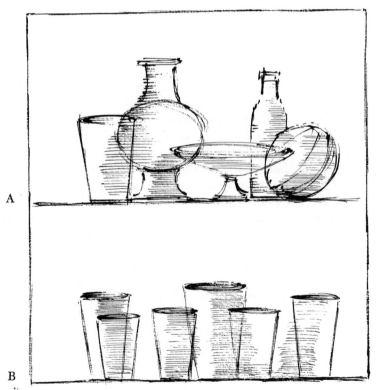

When there is no center of interest or there are too many separate centers of interest, the eye aimlessly scans the drawing and has no spot on which it can comfortably come to rest. In Fig. 19 (A), for instance, the center of interest is the largest container.

DESIGN

Even in the most realistic drawing there must be a sense of design, or underlying pattern. One aspect of design is composition —the arrangement of different objects into a harmonious whole; and another aspect is the arrangement of detail. There is design in the folds of a dress, the decoration of a pottery jar, the arrangement of leaves on a tree, and the way shadows and highlights fall. To be successful, a drawing should combine these elements in a proper relation. If one side of a drawing is completely unrelated to the other in form or texture, or if the weight is distributed without organization, the drawing is said to have been done without a proper sense of design.

PERSPECTIVE

When we arrange objects in space on different planes, we have to face the problem of perspective. Perspective is an optical illusion that makes all objects appear progressively smaller the farther distant they are from the eye. Thus, to take an obvious example, a telegraph pole that looms large when placed next to us will diminish in size the farther away it is, eventually to become reduced on the distant horizon to little more than a dot. This is demonstrated in Fig. 20. If we contemplate now the lines connecting the top and the base of the row of poles, we see that they form a triangle. Next, if we look at the rails in the same illustration, they appear wide in the foreground and narrow down into the distance, until eventually they meet at the horizon.

The second illustration in Fig. 20 shows a view of a room. As always, when you use scientific perspective, all parallel lines will narrow down with the progression of distance and will eventually meet on the horizon (eye level) at one point, the so-called vanishing point. The dotted lines in this illustration show the basis on which the perspective of this composition was built.

Unfortunately, this system does not necessarily guarantee artistry. You cannot rely on a rule or square to produce a masterpiece.

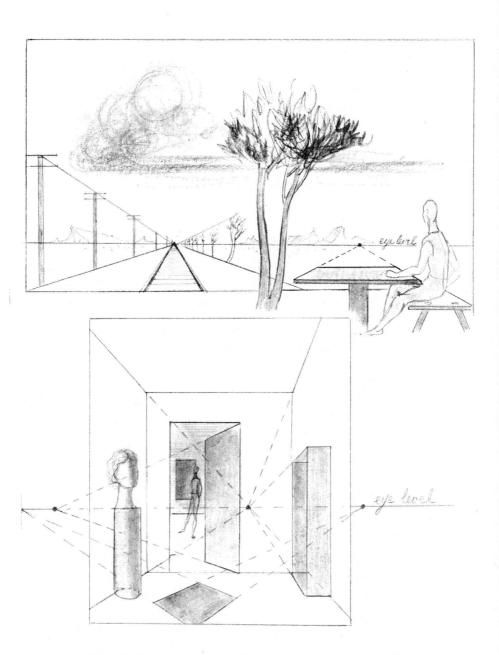

Fig. 20. Examples of scientific perspective outdoors and indoors, with parallel lines converging at horizon or eye level.

35

In fact, too strict an observance of the rules of perspective runs counter to the spirit of modern art. Perhaps we should say that after learning the rules you should feel at liberty to break them if you wish—judiciously, of course. Departures from rules are always desirable if they aid in achieving the "right" effect. Eventually it will be up to you to decide whether they do or they don't.

Some "tricks" that depart from the rules of scientific perspective follow. In Fig. 21 (B), for example, we see a table (compare it with the drawing of the table in Fig. 21 [A]). Here the parallel lines that are moving backward into the space will never meet at one point. The lines are, in fact, obviously diverging. A table drawn in this fashion will at once appear "modern" to us because it flaunts the established rules of perspective. The reason for this flaunting is that often (though certainly not always) conventional methods have become stereotyped and, hence, dull. Most modern artists, once having learned about perspective, choose to disregard its orthodoxy almost entirely. Such deliberate disregard is seen in Fig. 21 (B).

Perspective—different eye levels. In modern art when several objects are represented together, it is often the practice to make them appear as if each were seen from a different eye level. In Fig. 21 (A), the first object is seen at eye level, the second as we would see it from below, and the third as viewed from above. Now look again at Fig. 21 (B). You will note that all the objects are seen simultaneously from different eye levels. This "modern" device is commonly used in semiabstract painting.

The antiscientific system, it might be mentioned, derives its cue from Cézanne; it is no longer new. In fact, when used habitually it must be regarded as an academic convention.

TEXTURE OF OBJECTS

Besides having shape and color, all objects possess texture. Texture pertains to the tactile quality of an object, the quality felt by touching it, as well as the impression the eye receives while viewing it. Thus we can speak of smooth, soft, slick, rough, grainy, or coarse texture, each of which can be interpreted or suggested in drawing. Fig. 22 shows four different studies in texture achieved (from top to bottom) with dry brush, charcoal, pen and ink, and felt-point pen. Remember that different textured lines are produced

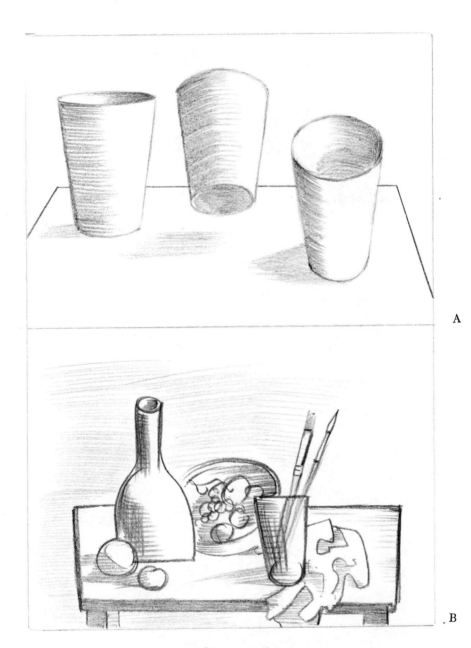

A

B

Fig. 21. A reversal of scientific perspective.
Objects here are seen from different eye levels.

Fig. 22. These different textures are achieved on the same rough-grain paper with dry brush, charcoal pencil, pen and ink, and felt point, in that order, from top to bottom.

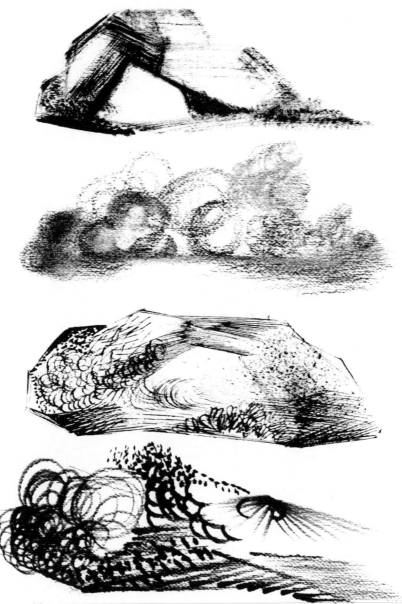

Fig. 23. Lighting of a head. In the first example, light areas predominate; in the second, with illumination from behind, shadows are in preponderance.

by different types of papers. The selection of a rough- or smooth-finish paper may be decided by the general effect you want to produce.

LIGHT AND SHADE ON OBJECTS

The impression of three dimensions—that is, of bulk, or seeing an object "in the round," as the saying goes—is achieved by shading and the use of highlights. Lines alone, as we have noticed before, will not give us plastic effects.

When we speak of light, we must first consider its source and the direction of rays in relation to the object. Two examples are shown in Fig. 23. In the first drawing the light enters halfway between the front and the side. In the second the light enters directly

from the side. For the representation of a head the most advantageous lighting is achieved when the light area considerably outweighs the shadow area. A completely frontal light, however, will tend to make a portrait appear flat. For most other objects, light directly from the side is better. Side lighting, to a greater or lesser extent, can dramatize any object, from a box to a bouquet of flowers or bowl of fruit.

Besides coming from the side, the light source can also be placed high or low; and this, too, will account for characteristic effects, as shown in Fig. 24 (A) and (B). In A the tree appears lighted by the sun high in the sky, and in B the elongated shadows suggest a late afternoon light. Usually, the lower the light, the more dramatic the effect. This is especially true in landscapes.

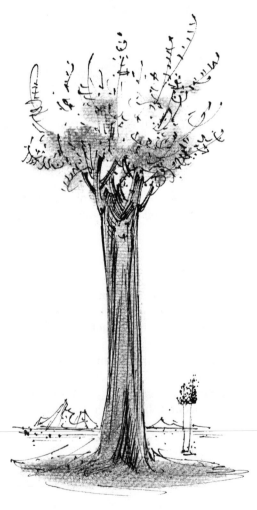

Fig. 24 (A). Shadows cast with sun directly overhead.

Fig. 24 *(B)*. With sun near horizon, more dramatic shadow effects are obtained than was the case in Fig. 24 *(A)*.

A dispersed light, such as seen outdoors on a heavily overcast day, will of course not produce good light-and-shade relations. Also, light that comes from different sources, such as windows and doors in various parts of a room, will account for confused light-and-shade effects. If indoor objects can be moved, there is normally little trouble in arranging them at a point near the window or door where the light will produce interesting shadows. One can always screen off other sources of light in the room if they are confusing. While artificial lighting can be used for the illumination of objects indoors, natural light is softer and, on the whole, preferable.

41

Figure Drawing

For average use Fig. 25 gives a fairly complete idea of the characteristic structure of the human body. Lacking a live model from which to work, students can make practice sketches from photographs in magazines or books. Sooner or later, however, studies direct from life must be part of every artist's training.

PROPORTIONS

In Fig. 26 (*A* and *B*), "ideal," or classic, proportions are represented. Of course, when drawing from nature, one will encounter deviations that are far removed from this conception. However, no matter how much the actual proportions may differ from the ideal, our studies must observe faithfully the actual image before us. If they don't we are likely to end up with unconvincing formalizations.

Proportions are the relative measurements of the body, such as, for example, the size of the head in relation to the rest of the body. The best method of establishing correct human proportions in our drawings is to choose one constant measure—such as the width of the shoulders, or a forearm, for instance—and compare this length with the width or height of other parts of the human anatomy. A practical method of doing this is shown in Fig. 27.

Hold a pencil vertically, with arm outstretched, while facing the model (see Fig. 27). When measuring with the right arm, close the right eye while the left eye remains open. Then the chosen

Fig. 25. Opposite: Schematic drawing of the human body.

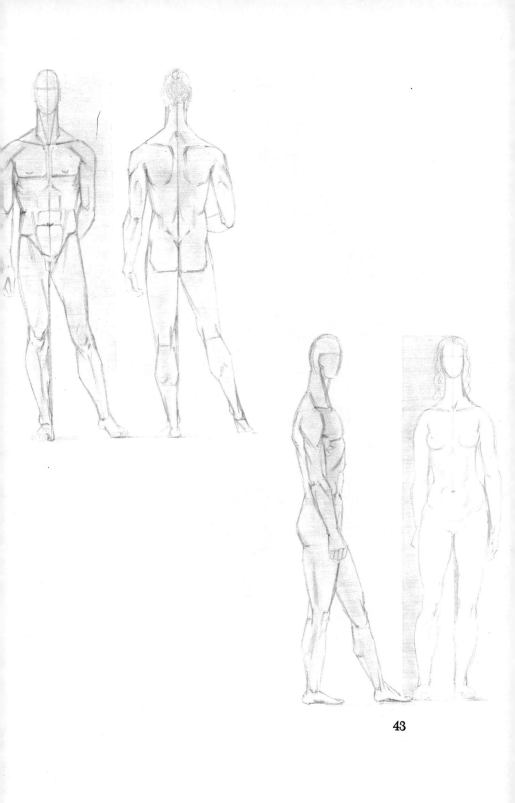

43

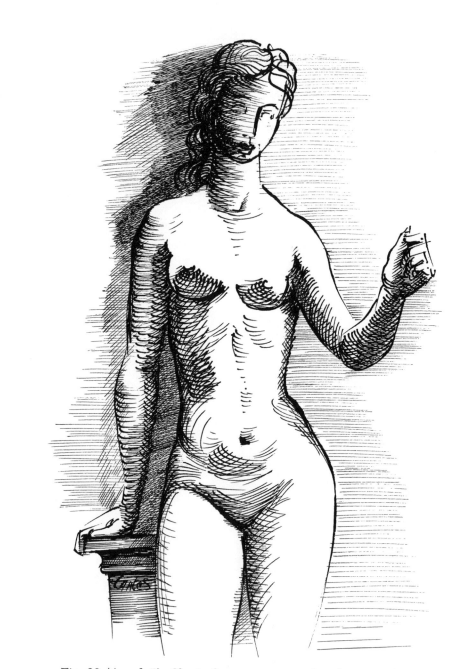

Fig. 26 (*A* and *B*). Classic figure proportions based on Greek statues.

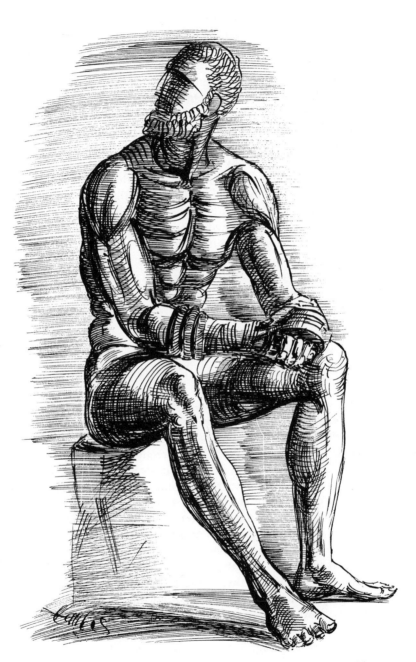

45

portion of the body is measured by eye against the length of the pencil. The tip of the pencil will mark one end of the measure, and the other end will be established by sliding the thumb up the pencil to the correct position. After this measure is noted, the pencil (with the thumb still held in the same place) can be used to measure vertically, diagonally, or horizontally—in fact in any desired direction—to establish how many times the first portion of the body measured falls into the rest of the figure's height or width. In this way the relative measurements of arms, legs, neck, head, and all other parts of the body can easily be arrived at.

In general, the body measures 7½ times the length of the head. The head and the trunk equal slightly more than the length of the legs. The navel is three heads down. With the arms at the sides, the hands reach halfway down the thighs. The width through the hips equals 1½ heads (in the male figure).

When it comes to establishing smaller proportions, such as a nose, mouth, or eye, this method is not practical. Details like these need more than a mere approximation. The subject of heads is taken up on pages 53-57.

AIDS IN DRAWING FIGURES IN MOVEMENT

The use of underlying geometric forms, as suggested earlier, can make the drawing of any object simpler. However, when you are drawing a head or a figure, especially a figure in action, the mechanics become easier if you use directional lines first. For any animate object—and by that I mean animals as well as humans—it is almost essential to set down the movement, as it were, first. Figs. 28 and 29 demonstrate the method I have always recommended. The first stage departs little from the traditional device of using matchstick drawings to establish positions of arms and legs in movement. When this has been done the body can be rounded out as in the second group of illustrations in each of these examples.

You may ask how can we best find the correct location of parts of the body while in movement? Observation and practice is the only way. With experience you will find that the eye becomes a reliable measuring instrument and the hand its faithful servant. While you are learning, first-hand observations have no substitute

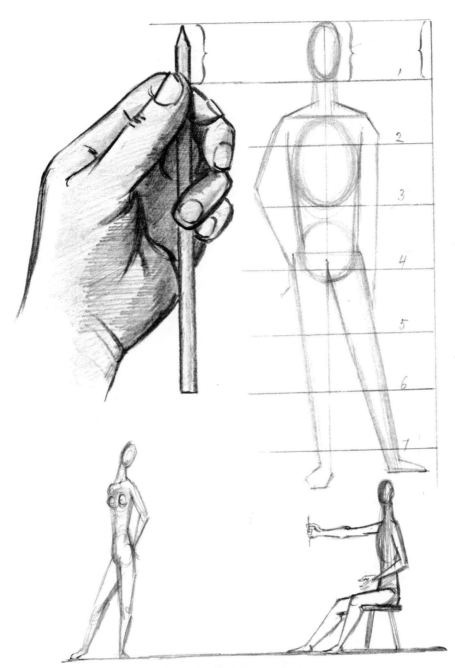

Fig. 27. Method of measuring human proportions.

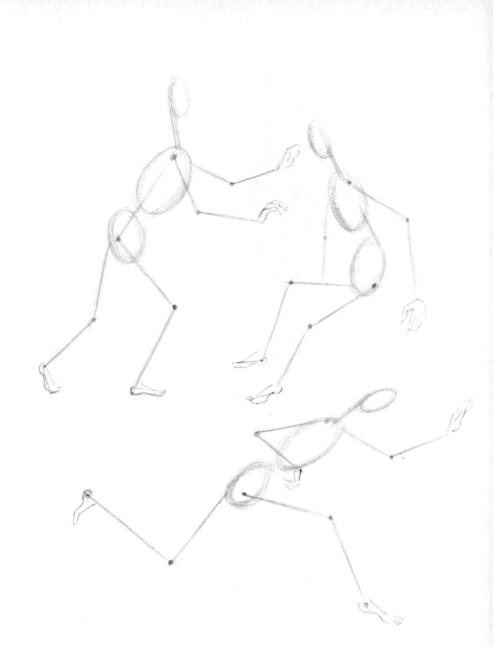

Fig. 28 (A). Body movements indicated by directional lines.

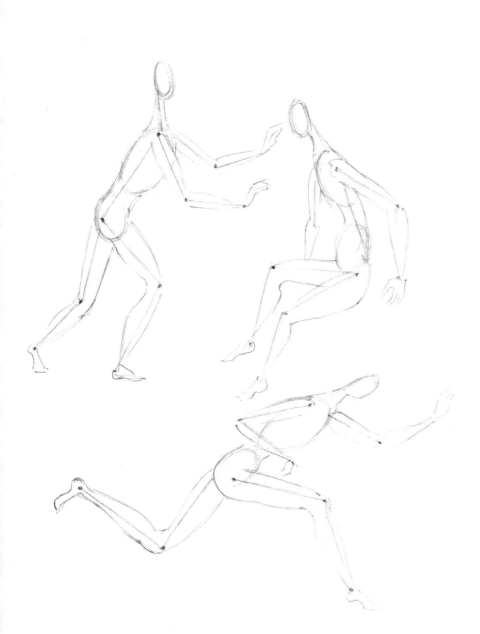

Fig. 28 (B). Development of the same figures into rounded outlines.

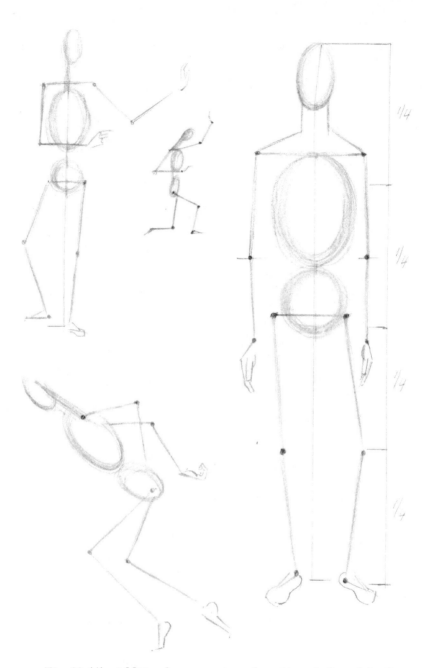

Fig. 29 (A). Additional movements and positions indicated by lines.

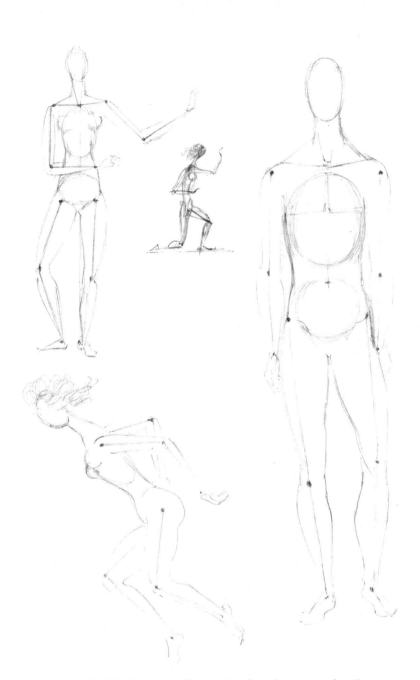

Fig. 29 (B). The same figures developed in more detail.

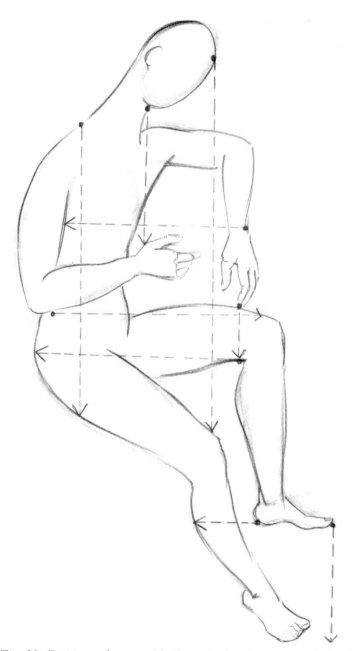

Fig. 30. Positions of parts of body arrived at by means of plumb lines.

other than photographs and the study of drawings and paintings by the best artists of both past and present.

One other aid in drawing: you can verify the positions of limbs in movement by means of lines—the so-called *plumb* lines—as demonstrated in Fig. 30. These plumb lines are constant, whereas all other lines circumscribing the body deviate in various degrees from these constants.

DRAWING A HEAD FROM LIFE

As always, when you start a drawing, simplification, or geometry, should be the rule. The basic, geometric forms of a head are seen in Fig. 31, and the finished drawing of the head is shown in Fig. 32.

The first principal aids in the construction of a head are the vertical axis and the horizontal parallels. These are demonstrated in Figs. 31 and 33 (top). Depending on the position of the head—bent sideways, down, or upward—the axis as well as the parallels will take on different positions (see second and third groups in Fig. 33).

Exact proportions of features will, of course, vary with each individual. Portraiture is one thing, however, and drawing "a man" or "a woman" is another. For establishing individual facial proportions (that is, a likeness), the use of a pencil as a measuring device is quite inadequate. Here it is necessary to rely on observation rather than on actual measuring, such as described at the beginning of this chapter. To aid in this we should visualize a triangle formed by the outer corners of the eyes and the base of the nose (see Fig. 34). The steep or the shallow triangle (according to the model's face) will at once establish the major proportion—and thus the characteristic of a particular head. When we arrive at one definite relation, all other parts of the head, such as the height of the forehead, the distance between nose and mouth, and the length of the chin, can be more easily established. All we have to do is to compare these distances with the length of the nose as determined by the triangle.

For general use in drawing heads, there are standard rules for proportions which are useful as a guide but should not be followed too slavishly. Again, there is no substitute for observation and con-

53

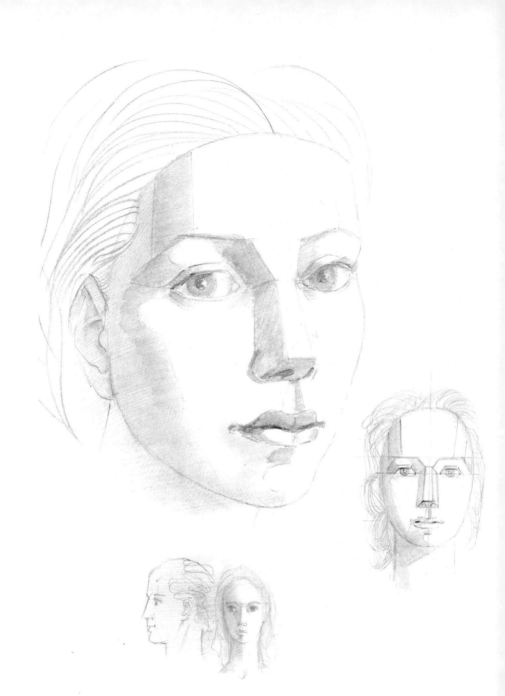

Fig. 31. Simplified, geometric renderings of a head help to establish main features.

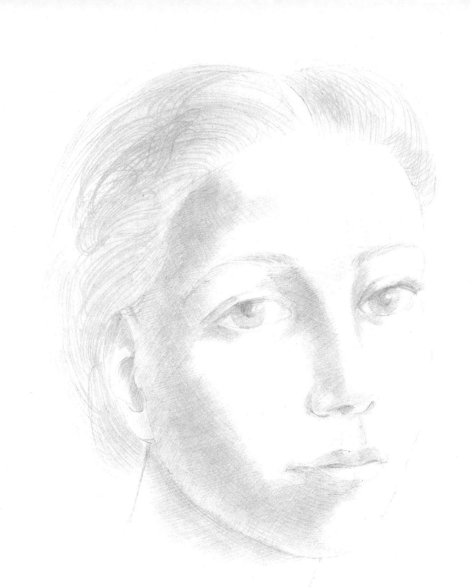

Fig. 32. The same head, redrawn from the preliminary sketch opposite.

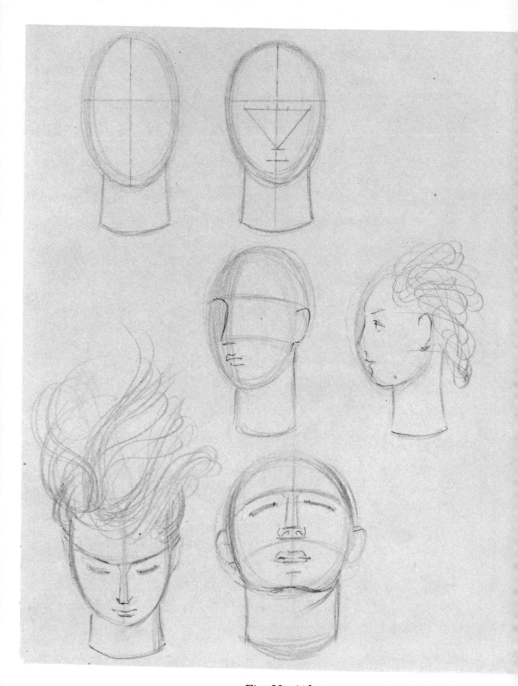

Fig. 33. Aids in construction of a head.

Fig. 34. Aids in finding characteristics
of features (see notes on page 53).

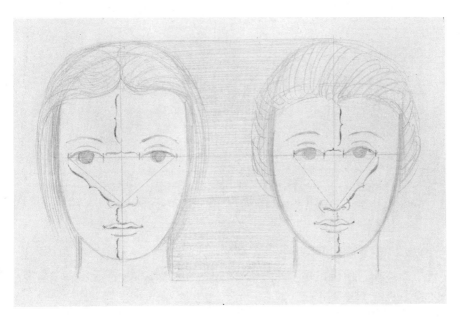

stant practice; but these rules, like all others in matters of art, are
useful as checks where spontaneity may have carried you a little
further from reality than desirable. The general proportions are as
follows:

The eyebrows and the tip of the nose divide the adult face into
three equal parts (the eyebrows divide a baby's face into two parts).
The distances from the hairline to the eyebrows, from the eyebrows
to the tip of the nose, and from the tip of the nose to the chin are
approximately equal. These are the so-called ideal proportions of
mature features, as shown in Fig. 32.

In addition, the eyes are separated horizontally by the length
of one eye, and the top of the ear is level with the eyebrows.

Landscape Drawing

The most important element in a naturalistic landscape is space and, with it, the representation of spatial perspective.

PERSPECTIVE IN LANDSCAPE

Perspective, or the suggestion of distance, plays a leading role in spatial arrangement. Although we need not necessarily adhere too closely to the principles of scientific perspective, which were discussed on page 34, an approximation of these basic rules must be observed if a degree of realism—as opposed to abstract or semi-abstract drawing—is to be achieved.

In the painting of a landscape, atmospheric perspective is an important element. This means the weakening of the intensity of colors with the increase of distance. For example, in a painting even the strongest red will, in the distance, lose its hue and fade into a bluish mist. When we are working without colors, atmospheric perspective can be suggested by varying the strength of lines or tonal values. Distant objects in a naturalistic drawing can be made weaker in tone and thinner or less distinct in outline, as in Fig. 35. This, to be sure, is not a must; for, if we work in that style, we may apply a sharp focus throughout the entire picture, as in Fig. 36. We may also go to the other extreme and give the entire scenery a blurry definition, as in Fig. 37.

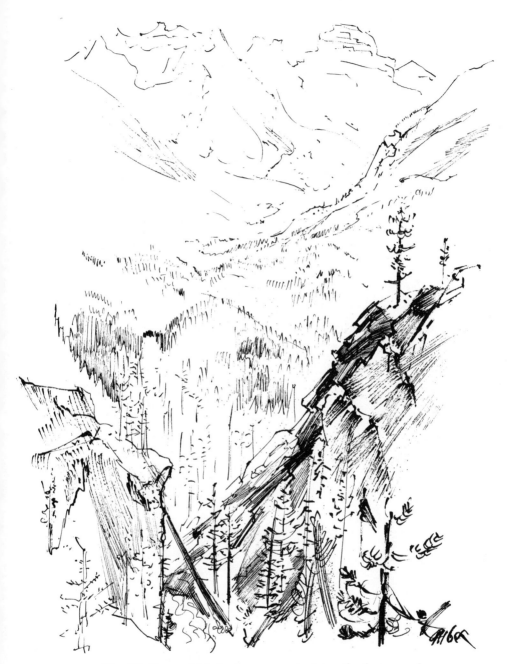

Fig. 35. Pen-and-ink landscape emphasizing the foreground

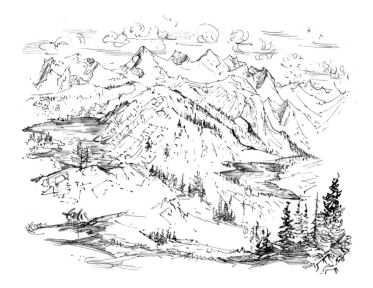

Fig. 36. Sketch showing equal emphasis in foreground and background.

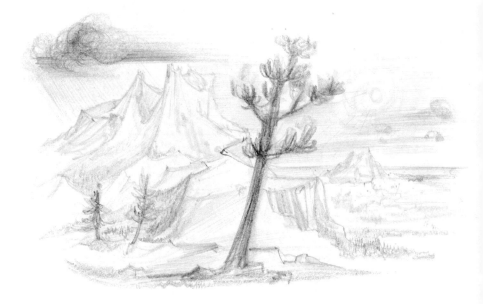

Fig. 37. Pencil drawing suggesting soft, atmospheric effects.

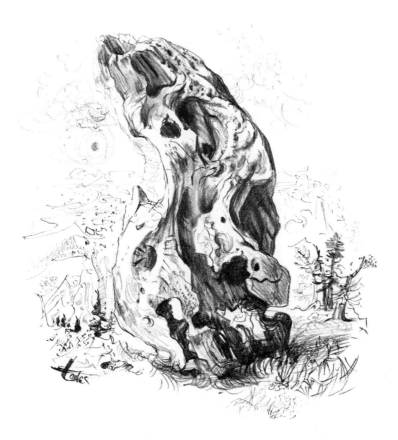

Fig. 38. Landscape and driftwood drawn with charcoal pencil.

COMPOSITION IN LANDSCAPES

A landscape must be observed from a good vantage point; or, should this be difficult to achieve, the position of certain objects must be judiciously shifted on the paper to create an interesting and well-balanced composition. The composition of a naturalistic landscape encompasses three planes: the foreground, the middle ground, and the background. In these sections natural objects, or motifs, in proper scale should be suitably arranged. For example, in Fig. 38 the foreground motif, representing a piece of driftwood, dominates the entire scenery. In the middle ground are a few trees, much reduced in size; and in the background is a rocky mountain, drawn less distinctly to suggest distance.

61

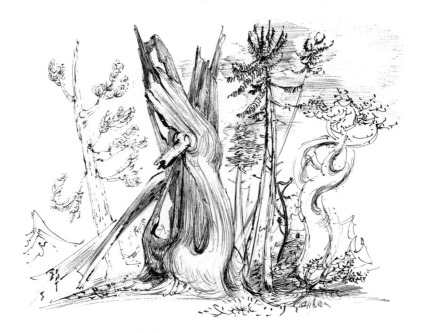

Fig. 39. Study of contrasting forms.

CONTRAST OF FORM AND COLOR

By the juxtaposition of different forms and textures we can create interesting contrasts. In Fig. 39 various kinds of trees are assembled in a composition. The strategy of introducing such diverse forms was to create greater interest. While, it is true, overdiversified forms may create a confused pattern in a drawing, there is perhaps an even greater danger of monotony when too many similar forms are repeated. As in all things, aim at proper balance.

In all types of drawing or painting, contrasts of color lend liveliness to a theme. Dark areas against light or light against dark should be part of our over-all planning.

TENSION AND RELAXATION

There is another form of contrast. By interrelating static and dynamic lines, a drawing can be made to express animation. The dynamic thrust of the tree stump and the trees on the right of Fig. 40 is contrasted with the static treatment of the tree on the left.

EMPHASIS AND FOCAL POINT

In a composition, emphasis should be given to the object that you wish to have dominate your composition. This can be done either by the size of the object or by the weight of line or shading. All other objects should, to a greater or lesser extent, be subordinated to the main object or theme; they should neither distract nor minimize its importance. Of course, the dominating motif or focal point can be made up of a group of objects that share the center of interest. As in music, successful drawings or paintings have equivalent areas of quiet and they have crescendos that build up to a climax. Without a climax your story or music or drawing meanders hither and yon.

Fig. 40. Tree patterns in a landscape.

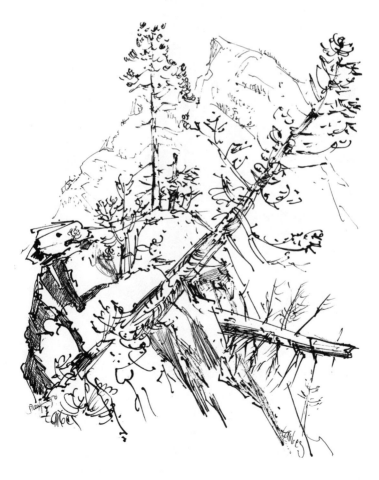

COHERENCE

A composition is coherent when all its parts serve one end—
to bring about a harmonious relationship of everything that con-
tributes to its theme. In a theoretically perfect drawing the removal
of a single element would disturb the whole composition. Hence
coherence refers not only to a story that may be told in a drawing
but to the placing and interrelations.of each object. These objects,
or "formal elements," can at times be more abstract than literal.

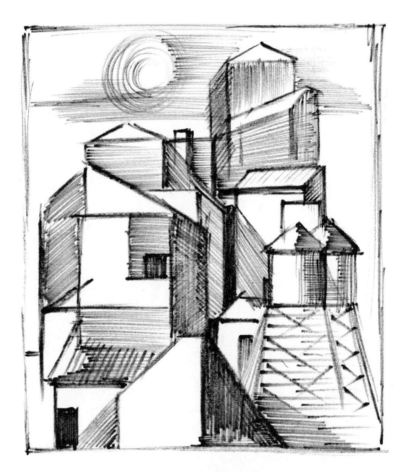

Fig. 41. Formal arrangement of architectural shapes.

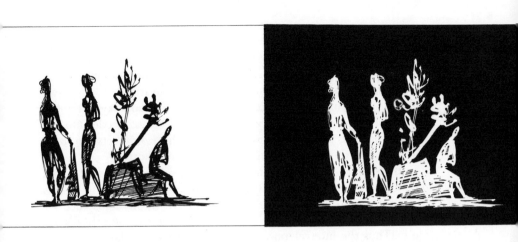

<div align="center">A B</div>

Fig. 42. In *A* the white background is in proper proportion to the weight of the figures. The reversed illustration (*B*) shows a disproportion of positive and negative values.

This is demonstrated in Fig. 41. Here a variety of abstract shapes suggesting architectural structures has been combined to create a cohesive pattern. Even if we do not consider the identity of these shapes (as buildings), the over-all design has a feeling of unity or coherence.

POSITIVE AND NEGATIVE SHAPES

Positive shapes are the solid objects that make up a composition, and negative shapes are the spaces around them. The organization or proportion of these shapes plays an important part in the structure of a composition. Although in graphic work the problem of the negative shapes is less acute than in painting (because the negative space is always the white of the paper), due consideration should be given to this question.

Too much or too little white or black area can spoil the effect of a drawing. In Fig. 42 (*A*) there is enough strength in the drawing for it to hold its own against the background, while in Fig. 42 (*B*) the same figures (shown in reverse) are overwhelmed by the background. In other cases the opposite might be true.

SKIES

A sky is either an empty space or one filled with cloud formations. In either case there are two important considerations: where should the sky appear darkest, and where lightest? In Fig. 43 two solutions are shown. In the first drawing (A) the dark sky at the top and the lightness at the horizon make the horizon recede into the far distance. In the second drawing (B) the horizon meets the darkened sky and the distance appears to be much shorter.

In assigning a certain space to the sky, remember that the area of the land either will be subordinated to the sky, as in Fig. 44 (A), or will dominate it, as in Figs. 47 and 48. In the first instance we may speak of a "worm's eye" view; in the second, of a bird's-eye view. Thus the interrelation of these areas will, in a large measure, determine the style of an entire landscape composition.

Cloud formations are of two general types. These are shown in Fig. 44 (A and B). In A the clouds appear round and billowy, while in B they are wind-blown and spiraling. In drawing B the clouds form diagonal lines at the bottom, and this creates an impression of a surging movement. The effect of plasticity is achieved by the soft shading. Fig. 45 shows different ways of treating clouds when working in pen and ink; the same softness cannot, of course, be achieved in this medium.

MOUNTAINS

The appearance of mountains varies greatly, depending on whether the surface is composed mostly of rock or of earth and on the nature of vegetation that grows over it. As a general practice, when drawing from nature, faithfully observe these characteristics, for no matter how much freedom one seeks to attain, it is important to render the rock formations authentically. When you are handling a completely fantastic theme, the case may be different.

For the purpose of leisurely study I find it practical to maintain in my studio a collection of small rocks of all descriptions. These serve as models for mountain formations. In Fig. 46, for instance, next to the withered tree trunk, I sketched two stones. In a final composition one or the other of these models might well be sketched to represent a massive mountain. As a point of interest, the specimen on the top of Fig. 46 was drawn with a felt-point pen, after which a few accents were added with regular pen and ink. The rock

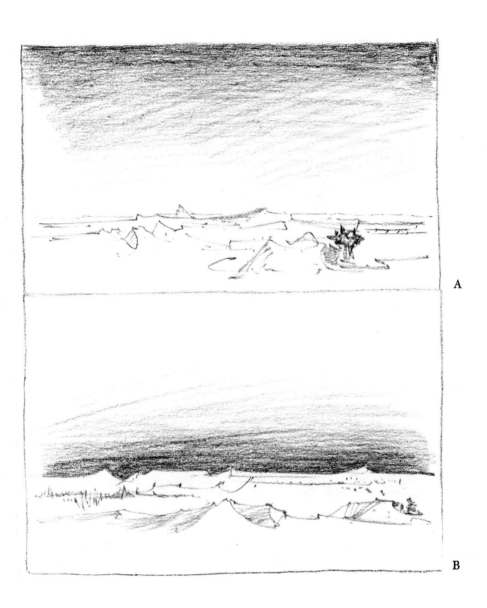

A

B

Fig. 43. In drawing A the sky appears dark at the top and light at the horizon. This allows the horizon to extend into the distance. In the second drawing (B) the sky is darker at the horizon, thus making the distance appear shorter.

67

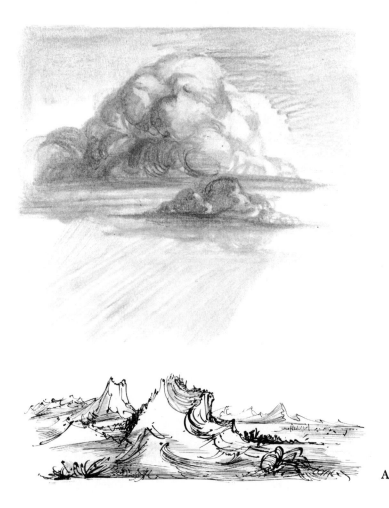

A

Fig. 44 (A). Cloud formations are drawn in charcoal, the landscape in pen and ink. Fig. 44 (B), opposite, shows another sky rendered in charcoal. A smooth paper was used for both studies.

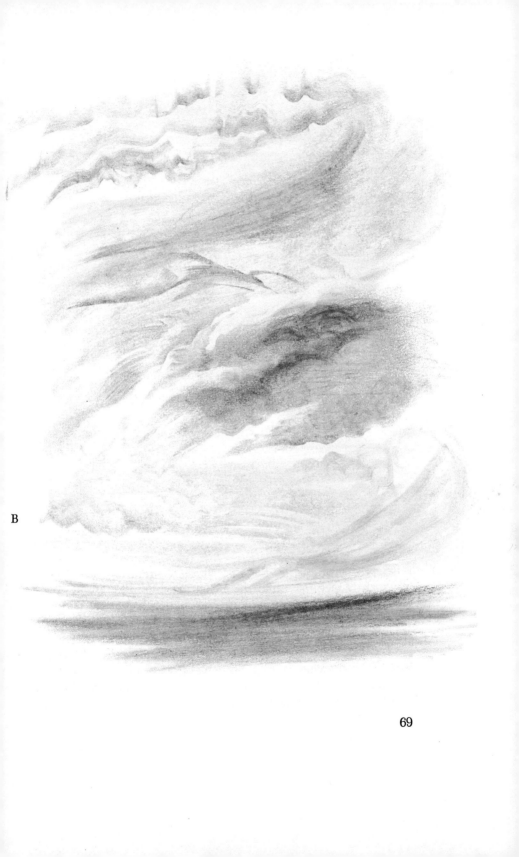

B

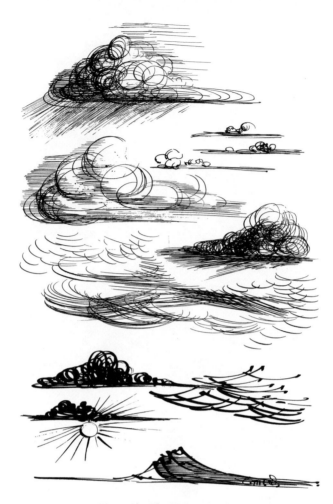

Fig. 45. Cloud formations drawn in pen and ink.

is curvilinear, in contrast to the rock at the bottom of the same sketch, which is rectilinear and somewhat crystalline in structure. This second rock was drawn with a hard pen point, which was more suited to convey its quality.

Fig. 47 was drawn directly from nature in British Columbia. The same scene, viewed from a different vantage point, is shown in Fig. 48. The drawing in Fig. 49, however, was not done from nature. This landscape was invented and the rock formations "distorted" for the sake of dramatization.

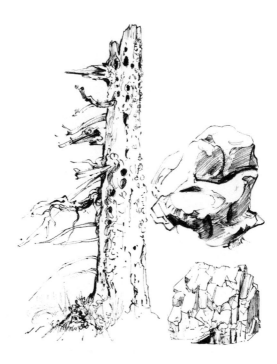

Fig. 46. Dead tree
trunk and two small
rocks.

Fig. 47. Mountain panorama in British Columbia.

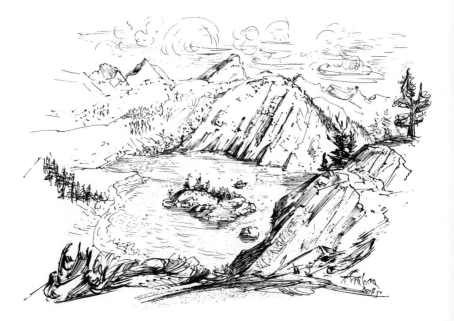

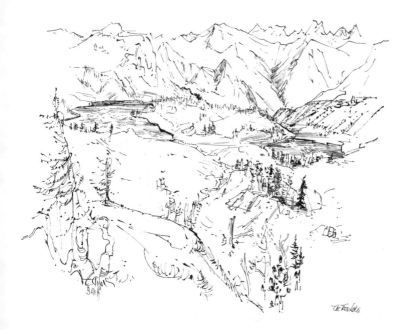

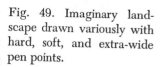

Fig. 48. A more distant view of the landscape in Fig. 47 drawn in fine lines throughout.

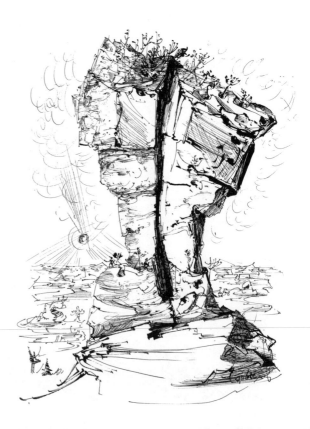

Fig. 49. Imaginary landscape drawn variously with hard, soft, and extra-wide pen points.

THE GROUND

Rendering the characteristic of a particular kind of ground is much more difficult with pencil or pen than with paint. The nature of a ground—be it grass, sand, earth, or a patch of stone—is quickly identified by color in a painting. When ground is drawn without color, however, individual texture becomes all-important.

Drawings of various and typical textures of ground elements are shown in Fig. 50. Here it is obvious that the effects are largely dependent on the nature of the drawing materials I have used. However, certain obvious differences, such as exist between grass and stone, would be made apparent by the different handling of the pencil in shading, that is, in the achievement of texture.

WATER

Here, three conditions are normally found: water with little or no motion, such as in a woodland pond; water with flowing motion, as in rivers; and sea water with waves. See Fig. 51. These three conditions can be represented in a variety of ways, and the study of many different artists' work is recommended. This suggestion of studying a variety of techniques applies, for that matter, to all subjects. Visit museums and art galleries to study, and you will gain inspiration from the masters while developing a technique of your own.

TREES

Whether we draw a tree in a realistic or impressionistic manner, following the characteristics of the particular type of tree is perhaps even more important than it is in drawing hills or mountains. While we can and often must take liberties, these should not extend to the point of vagueness wherein a row of poplars might equally be taken for a row of pines. Even the impressionists made it quite clear what type of tree they were drawing or painting, although the actual species was left to the observer's imagination.

While considering the question of foliage, one might quite easily be tempted to pay attention to the shape of each individual leaf. In landscape drawing, however, quite obviously this cannot be done. Individual leaves are one thing, and *foliage* is another. Leaves, as such, are better material for a still-life study. In land-

73

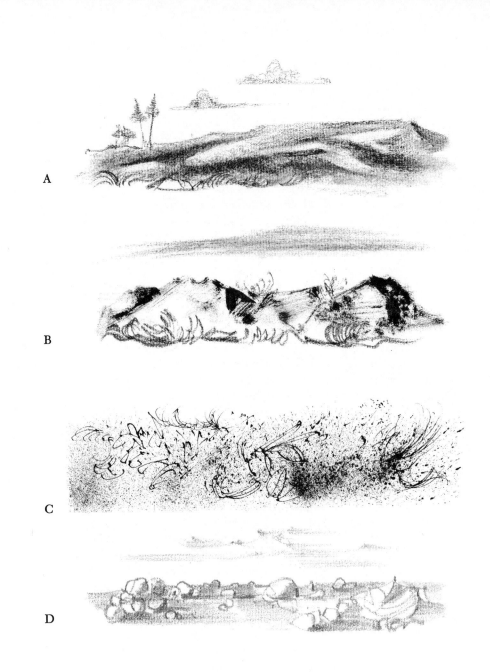

A

B

C

D

Fig. 50. Ground textures drawn on medium-rough
paper with (A) vine charcoal, (B) dry brush, (C)

ink spatter, (*D*) soft pencil, (*E*) hard pencil, (*F*)
pen and ink, (*G*) round sable brush, (*H*) felt point.

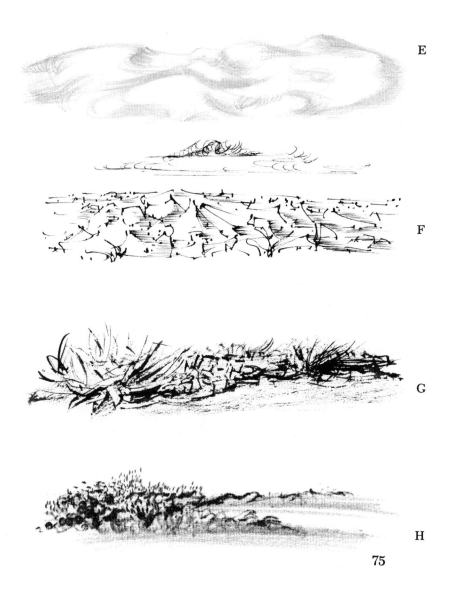

E

F

G

H

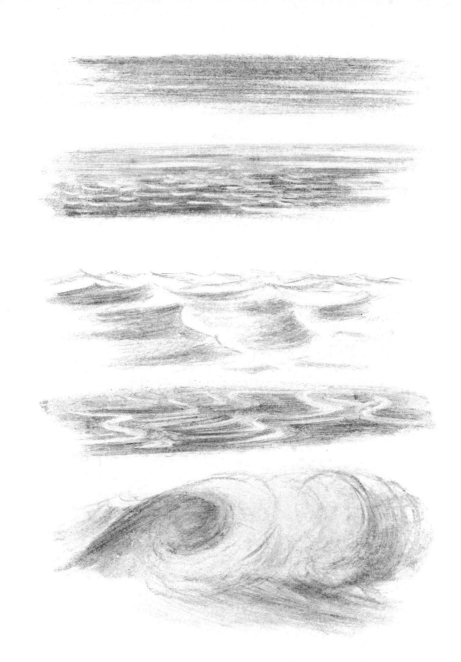

Fig. 51. Studies of water drawn in pencil and charcoal on smooth paper.

scape renderings it is the collective appearance of the foliage, the sum total of the leaves, that interests us. Thus we must pay more attention to the *texture* of foliage en masse. To some extent, of course, the characteristic of the individual leaves will show up in a

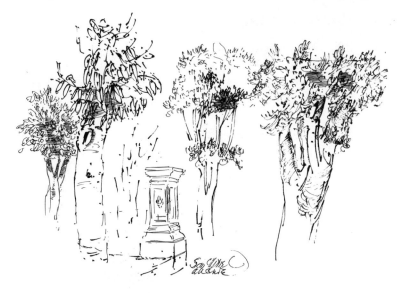

Fig. 52. Textures of foliage drawn in pen and ink.

mass representation of foliage. Figs. 52, 53, and 54 display several different treatments of trees and foliage.

Not only do trees differ in leafage, but their trunks and branches show differences in size, shape, and texture. Age also contributes its effect. Old trees have always interested me, and the study of a dead trunk in Fig. 54 is one of many such drawings I have made.

ANIMATION OF LANDSCAPES

It is conspicuous that none of the landscapes reproduced in this book are animated; there is no evidence of the presence of either humans or animals. The reason for this is simply my predilection for landscapes with a minimum of human or animal intervention. Your preferences may run in the opposite direction, and

77

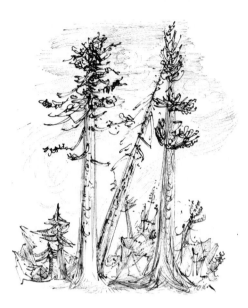

Fig. 53. Textures of Douglas firs. (Pen and ink.)

Fig. 54. Study of a dead tree trunk. (Pen and ink.)

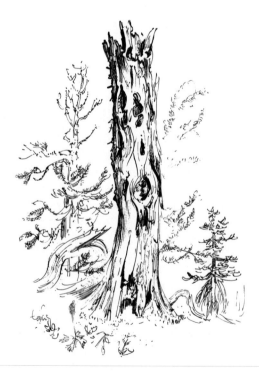

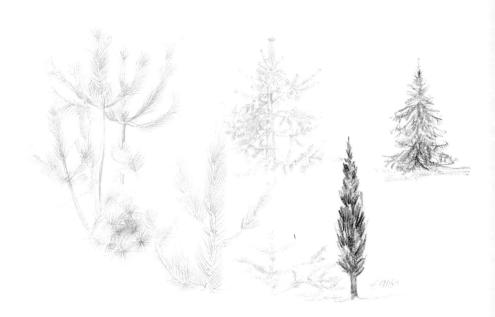

Fig. 55. Characteristics of spruces and pines. (Pencil.)

there is certainly no reason why figures (or animals) cannot be introduced incidentally or play a major part in a landscape composition.

In practice, the inclusion or exclusion of figures—and man-made objects too—in a landscape may be decided by the prominence they would receive from their placement: in the foreground, middle ground, or background. The first choice would place emphasis on figures or architecture and leave the landscape as a more or less incidental background. Placing the figures or architectural motifs in the middle ground will reduce their importance and allow the landscape motifs to prevail. When figures or dwellings move into the background, we can speak of a pure landscape composition.

The important thing to remember when planning a composition is that there should be no rivalry between the various motifs. In the case of a landscape, either the landscape should be dominant or the people or architecture should be featured. When all elements bid equally for attention, the effect is never harmonious.

79

Other Drawings
from Nature

PLANTS

Like all organic matter, plants, too, have anatomy. The anatomy of a leaf, for instance, presents itself in a very definite design. Hence, when drawing a leaf (Fig. 56), start with the spine, which divides every leaf in bilateral parts, and then study the palmation.

Several sketches of plants are illustrated in Fig. 57 (A, B, and C). These examples show a plan of growth common to all plants. Once acquainted with this general plan, we can re-create or, one might almost say, invent plants to gratify our imagination. In any event the multiplicity of floral forms lends itself to endless variations and combinations which can be rendered in realistic, semirealistic, or abstract fashion.

To gain a good fundamental knowledge of plant structure, study many different kinds of plants. The easiest way is to copy meticulously at first several plants found in the garden or the meadow, or, if you live in the city, as many as you can afford from the florist. Actually, the more humble the plant, the more attractive it is pictorially. From my point of view a common weed makes a more interesting model than the most gorgeous or elaborate hothouse flowers.

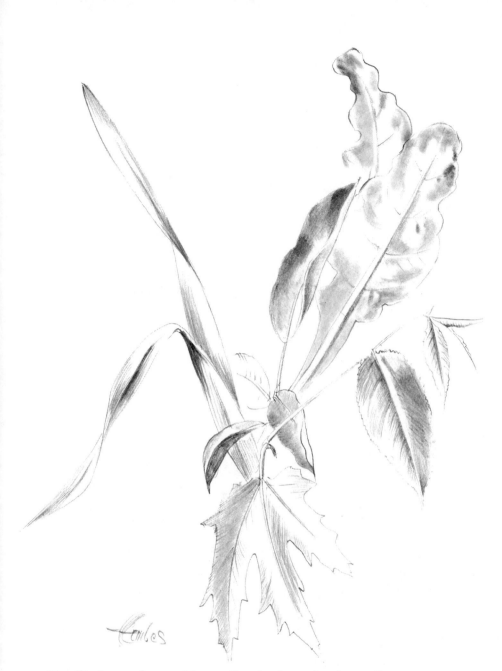

Fig. 56. Leaves drawn with a medium-hard pencil and a tortillon stump on smooth paper.

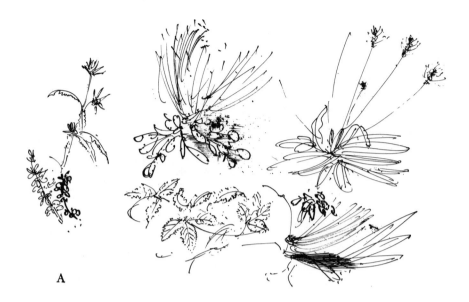

A

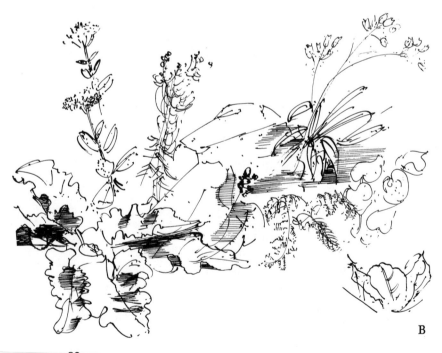

B

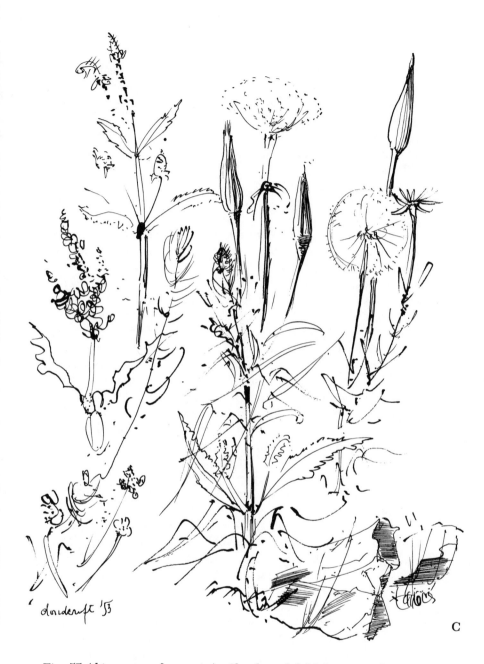

C

Fig. 57 (this page and opposite). Sketches of field flowers and weeds.

STILL LIFES

Arrangements representing inanimate objects as well as flowers and fruit are classified as still lifes. The inanimate objects can be everyday man-made things: pots, pan, bottles, tools, musical instruments, decorative things such as sculptured objects, or anything else that takes your fancy. Natural objects—and we can think of shells, stones, driftwood, and the like—are also very desirable motifs for a still-life composition.

Although I have mentioned quite a variety of motifs, it is best to select only a few suitable ones at a time, especially in a first attempt at a still life. In fact, it is always a good rule to limit oneself to simple arrangements. There are exceptions, however. The seventeenth-century Dutch painters, for example, included in their still lifes everything they could find, even birds' nests and insects, without sacrificing good taste. What was fashionable then, however, no longer has currency in our age. As a matter of fact, no artist has ever made a mistake by keeping a composition relatively simple.

Still-life composition. Not only is a still life perhaps the best first project for a beginner, but it will prove sound practice if he designs one with a reasonable number of interesting shapes and reduces these on paper to abstract or semiabstract geometric forms. Thus by first giving attention to formal relations rather than to particularization, he is not likely to bog down in nonessential details. There is plenty of time for embroidery after the main shapes have been organized into a pleasing composition.

Once the objects to be drawn have been assembled and arranged for a still life, tracing paper should be affixed to the drawing board and a piece of vine charcoal used for lightly outlining the composition.

The main masses, as already suggested, should receive first attention. These make up the scaffolding of the arrangement. They must be organized or reorganized until a distinct and harmonious pattern of geometric shapes emerges on your paper. Somewhere toward the center of the composition there must also be one dominant pyramid which encompasses the focal point.

As seen in Fig. 58 (A), the interdependence of the various geometric figures, the shallow or steep inclines of the pyramid, the dimensions and positions of the rectangles and circles will determine whether a composition is satisfactory enough to proceed with the

A

Fig. 58. The scaffolding of a still life composition (A). Below, the same composition redrawn and finished with a soft pencil in chiaroscuro (B).

B

details. At this point there is still time to make some changes in outline if we need to before proceeding to the next step.

When the scaffolding has been perfected, individual forms can be drawn in their respective positions, as in Fig. 58 (A). These need not correspond exactly to the models in front of us—we must always allow ourselves freedom of adaptation as we go along. Furthermore, the details we draw in over our scaffolding can at times overlap or come within the geometric outlines if the drawing is improved by doing this.

Once the composition is arranged to our satisfaction, we may complete it with realistic details. If the drawing has been worked over too much or the underlying mechanics show, either trace or redraw the still life freehand, omitting the first stages or the geometry of your first construction. The same composition, but conceived in chiaroscuro, appears in Fig. 58 (B). Here the strong light-and-shade contrasts lend plasticity to the still life.

For almost any type of formal drawing, especially before a student has had much practice, it is well for him to work out a composition carefully in this manner, then use this first sketch as a model for a finished drawing. The same is true for painting; though in oil painting the charcoal sketch on canvas will, of course, be hidden by the paint.

STUDY OF FOLDS

Perhaps more than with most objects, the plasticity of folds depends on a proper distribution of light and shade. In Fig. 59, the drapery, placed on a life-sized manikin, received artificial lighting. Such lighting is likely to produce stronger chiaroscuro effects, for the shadows are more sharply defined. Because of their mobility, draperies can best be studied when they are placed on inanimate objects such as a manikin.

When draperies or folds are to play an important part in a drawing, use a pencil, charcoal, or crayon to render them. Pen and ink is more difficult to master, for here, to represent shadows in a realistic manner, an elaborate crosshatch technique will have to be employed. But when rough materials are being modeled, crosshatching will do well.

Fig. 59. Study of folds made with synthetic charcoal.
The drapery was placed on a life-sized wooden manikin.

Notes and Short Cuts

1. Drawing is a relatively inexpensive vocation or avocation—whichever the case may be—so it is especially worth while investing in materials that will give you the best results in the shortest time. At the beginning obtain adequate equipment: good quality drawing papers as well as sketch pads, medium to soft pencils, crayons, charcoal, an India ink fountain pen as well as an ordinary pen with points of varied thickness, and a sable hair brush for wash drawings. See part I.

2. Try out pencils, charcoal, crayon, and pen on the different types of paper of rough to smooth surface. Make practice strokes to get the feel of your equipment. Do long and curving strokes to suggest the growing stem of a flower or plant or tree trunk; make other strokes short and rough to suggest grass forms and other material objects. Make thick lines, thin lines, tapering lines. With a pen the downward strokes will be thicker, except in the case of a ball-point pen, where there are no variations.

Make continuous lines and broken lines, and note the effects of each. Work with the pencil or crayon in writing position, then with the lead held between thumb and forefinger flat against the paper for broader strokes, as shown in part I. It is important to know the different effects you can obtain with the same instrument—by using it at different angles and by applying different amounts of pressure.

By using the same tools on different papers you will also discover the variety of textures they automatically produce. Make calm or passive lines (straight and parallel), angry lines (zigzag), and

graceful (sweeping) lines to suggest movement. Different types of lines are important in shaping the character of a drawing or painting (see part I).

3. Practice making outlines of simple, familiar objects on your sketch pad. To begin with, many artists find it useful to establish the main points of a composition and the shape of each object by putting in light pencil dots as a guide, then joining these dots with lines and developing the molding and shading of objects afterward. This is certainly not obligatory, but it does help to keep the composition within bounds. It is very easy to get excited while doing one part of a drawing, only to find in the end that you have made it too large or too small in proportion to the sheet of paper or out of scale with the other objects you had intended to put in.

If you don't favor the dot system, it is, in any event, necessary to complete in light lines the masses or architecture of a drawing before you start working on details. In other words, get your general outlines down first.

4. Don't be afraid of making mistakes. Everyone does make mistakes, and sometimes mistakes even turn out to be fortunate. Set out with a feeling that you are going to enjoy yourself and your work and that one wasted sheet of paper more or less won't ruin you. If you do this you will feel relaxed and uninhibited.

Keep drawing a favorite object until you are completely familiar with its shape and texture and are relatively satisfied with the impression you have made of it on paper. Then try drawing something else for a change and afterward return once more to the first object and redraw it. There is usually a noticeable improvement in your technique each time you return to redo an object that you have practiced earlier. You are less tense, your hand draws more freely —one might say more automatically—and with a greater confidence.

To begin with, I suggest that you select simple subjects to draw, such as a still life with fruit and a vase. Don't try difficult subjects, such as figures, at the start. Get some experience first. And don't be timid. Make bold strokes that have life in them, strokes that are expressive. A very good early project is to make a lot of strokes suggesting, quite abstractly, things such as trees bent by the wind, or water flowing down a fall, or a quiet landscape with little more in it than a horizon line and perhaps a tree or two. You will find this a fascinating practice and one that will help you to create

mood and character in more elaborate drawings later. A single powerful and sweeping line across the page can be an axis around which everything you add later will revolve; it can be your theme line to which everything is made subordinate.

5. When you have practiced freehand sketches of common objects, such as fruit, all kinds of vessels, or simple shapes of houses and the like, and have put in shading with the flat of the pencil lead (as the shadows appear in nature), take a new sheet of paper and build a still life or landscape composition, reducing all elements to geometric forms as suggested on page 84. Use the first worked-over design as a model for another freehand sketch. Try doing it separately in pencil, then in crayon, then in pen and ink on smooth and medium-rough drawing papers. Note the different effects you have obtained. Where you used pencil or crayon shading in the first sketches, try crosshatch shading with pen and ink.

6. When you draw figures or portrait heads, establish the main positions and shapes with faint dots on the paper first, then connect the dots with lines and build up the head. Check proportions as suggested in part II. Try many sketches directly from life on sheets in a pad until you learn to get the right proportions and an authentic shape for eyes, nose, mouth, and other features. Then try for a finished drawing on good sheets of drawing paper. The result will at once look more professional than the drawings on the sketch pad. If live models aren't available, sketch from photographs or other drawings. In other words, do anything for practice!

7. When drawing landscapes, decide which details you wish to include and which to omit. You cannot, of course, draw everything down to the last leaf of a tree. Simplification is always a saving device. Strive for a general impression and emphasize the objects that interest you most. Rearrange their position in the landscape if this makes a better composition. Remember about perspective and the foreground, middle ground, and background of a landscape (see part III).

8. Not only in landscapes but in any composition decide which elements should be emphasized and which minimized. Don't let too many details compete for attention. Build up a composition in asymmetrical balance as in nature. Arrange for a main point of interest or a focal point to which the eye can constantly return. This

should be a climax somewhere near the center of the drawing but not plumb in the center. See part III.

9. Wherever you go, observe objects, people, buildings, landscapes, with alertness. Make notes on small sketch pads for later reference in a drawing. You may find it a useful practice to observe some object or group of objects, such as a table set with a few natural accessories. After two minutes, turn away and draw what you saw from memory. Then look back and check where you went wrong. This will help to train the eye, memory, and hand for closer coordination.

10. There is no harm in working over sketches in the initial stages of study to correct mistakes, but don't leave it at that—redraw the same subject freehand and throw the first study away. Keep on drawing the same subject freehand until you arrive at a result that is near enough to the effect you are seeking and which at the same time appears unlabored and fresh. Naturally, a worked-over drawing will never appear spontaneous. When attempting a finished drawing (as opposed to a note or sketch), use an eraser as little as possible. As a general practice it is better to redraw than erase any large part of a drawing. The more you erase, the more tortured the paper becomes. You cannot redraw satisfactorily over a surface roughened or worn thin by too much erasing.

11. When attempting figures in action, make one or two quick, faint lines first to establish the main directions of movement; then place dots on joints where the main parts of the body will meet, as on pages 48-51. If you first create a feeling of movement with a single stroke of a pencil and then build a man or animal around the directional line, you are likely to achieve an animated, spontaneous effect. An obvious example of a directional line would be the angle of a man's body while diving or a horse's body while jumping a hurdle. Set down the angle of the movement, then develop a body around it.

12. Study light and shade by placing objects with the light coming from the side, or half from the front, or entirely from the front and from above or below eye level. You will find that the position of light can make some relatively uninteresting objects look interesting and some interesting objects look dull. Looking at a landscape through the window at different times during the day

91

will demonstrate this. There are certain hours when the view will inspire you to draw or paint and others when it will leave you indifferent. Morning, afternoon, and evening light are quite dissimilar. See part III.

13. Don't be addicted to convention. After you have learned to produce naturalistic effects, reduce a drawing to abstract forms and compositions or emphasize certain lines or proportions by distorting them to an extent, if this will add to the feeling or mood you are trying to convey. If it is height or shortness, fatness or leanness, spatial recession or whatever else, this can be emphasized by exaggeration. As in a caricature, a keener likeness or a deeper expression of an object's essential characteristics can sometimes be obtained by exaggerated delineations.

14. The shortest cut of all to good drawing is through strengthening your powers of observation (look at everything as if you had never seen it before) and through perseverance with pencil or pen in setting down these observations. There is really no substitute. As with everything else, whether it be music or sports or acting, the more constantly you practice, the better at it you will become—and quicker in execution. But guard against letting yourself get stale. Constantly record new impressions. Observe nature and find new ways of recording it. Study works of art in the museums or in books. Everywhere you will see new subjects and new perspectives which will both inspire and aid you in your technique.

15. Set yourself a project of making an abstract pattern. Arrange areas of light gray and black and of different outlines—rectangles, cubes, circles, ovals—one overlapping another until you have a well-balanced design. This study might be achieved first by cutting out different shapes of paper and arranging them flat on a board. Later you could translate the final arrangement into a pencil or pen drawing on paper, or a combination of both. Every composition, no matter how realistic, has a pattern which holds it together—a pattern of repetitive shapes or tones or textures. The artist's job is to make this pattern pleasingly rhythmic. That is why, when drawing from life, it is frequently necessary to rearrange the position of certain objects until an attractive design and pattern of tones are arrived at.

16. It may seem obvious, yet it is a point often overlooked when a student loses himself in this subject—keep pencils sharp. Sharpen

them to a tapering point constantly during work. A blunt end of a pencil produces woolly images. You can hardly achieve a high standard of work with a poorly sharpened pencil. Keep a razor-blade knife handy for sharpening. You will also find a sandpaper block useful for rubbing the lead into a pinpoint sharpness.

17. If you must guard against staleness, you must also guard against working when you are tired. When you are fatigued, your lines will grow heavier and spontaneity will have altogether vanished. Put the drawing paper and pencil away and start out fresh another time.

18. Often effective drawings show the use of different textures and an interplay of varied lights and darks. The shading of leaves or grass will be different, just as sunny and shady spots will provide contrast. If a drawing looks flat, this usually means that there is not enough contrast in texture or light and shade. It is never necessary to shade in every area. Also try out drawings with light washes of India ink in black or sepia (dilute ink well with water) for shadowy backgrounds; and, when this is dry, draw figures or other objects in pen and ink over this middle tone. Again, be sure to leave plain white areas in wash drawings for contrast and drama.

19. When you have finished a drawing, put it away for a few days; then take it out and look at it again. It will seem quite different from the way you remembered it, and it is in this new critical appraisal that you can learn best where you have succeeded or failed. If the drawing doesn't altogether please you, don't try to correct it and don't throw it away. Make a mental note of what is wrong and do a new drawing. Having learned from past mistakes, you should be able to make a new drawing that is almost sure to be better. Another way to cast a fresh eye, so to speak, on your work is to look at it in a mirror. At once you will notice whether things are out of proportion or balance.

20. All the foregoing is sound practice before you start to paint, which is what most artists want to do. Drawing in itself is an art, but it is also the foundation upon which successful painting is built. The principles of proportion, balance, harmony, light and dark areas, and all the other points discussed apply equally to painting. And when figures or flowers or trees or architecture are to be used in a painting, a knowledge of drawing is essential. The usual practice

in doing a drawing for a painting is to make the drawing on tracing paper first and then to transfer it to the canvas. A transfer paper can be made by rubbing a crayon (sanguine or bistre is best) over the entire surface of a blank piece of tracing paper. Insert this tracing paper, like carbon paper, between the drawing and the canvas and trace the outlines of the drawing with a pointed, blunt instrument.

Nulla dies sine linea ("Never a day without a line") was the standing phrase in the workshops of the old masters; and, to put it in the words of the great painter and draftsman Ingres, let us remember: "Drawing is the probity of art."

Thus, learn to draw first, and let painting be your second project.

Important Books on Art from Penguin

WAYS OF SEEING

John Berger

"Seeing comes before words. The child looks and recognizes before it can speak. But there is also another sense in which seeing comes before words. It is seeing which establishes our place in the surrounding world; we explain that world with words, but words can never undo the fact that we are surrounded by it. The relation between what we see and what we know is never settled." So begins this book, based on an acclaimed television series. It widens the horizons, quickens the perceptions, enlivens new vistas as we look at art, the world, and ourselves.

AN OUTLINE OF EUROPEAN ARCHITECTURE

Nikolaus Pevsner

This seventh revised edition of Nikolaus Pevsner's classic history is presented in an entirely new and attractive style. The format has been enlarged and the illustrations appear next to the passages to which they refer. Their numbers have swelled to nearly 300, including drawings, plans, and photographs. The book tells the story of architecture by concentrating on outstanding buildings and reads exceedingly well in its concentration and its combination of warmth and scholarship.

A DICTIONARY OF ART AND ARTISTS

Fourth Edition

Peter and Linda Murray

This dictionary covers the last seven centuries, up to Picasso and Pop Art. Short biographies of nearly 1,000 painters, sculptors, and engravers fill the greater part of it. These contain facts and dates in the artist's career, a note on galleries exhibiting his work, and an estimate of his style. The dictionary also defines artistic movements, terms applied to periods and ideas, and technical expressions and processes.

Distinguished Art Books from Penguin

THE HUDSON RIVER AND ITS PAINTERS
John K. Howat
Preface by James Biddle
Foreword by Carl Carmer

In the nineteenth century the compelling beauty of the Hudson River Valley inspired a group of landscapists who came to be known as the Hudson River School. Deliberately setting out to reflect a sense of national pride never before expressed by American artists, they portrayed the Hudson with a deep, almost mystical reverence for its natural state—its spectacular cliffs and chasms, its jutting rocks and vine-covered banks and swirling waters. The development of this first native-American school of painting is the theme of *The Hudson River and Its Painters,* which presents in large format more than a hundred handsome reproductions of works by Victor Gifford Audubon, Asher Brown Durand, Sanford Robinson Gifford, John Frederick Kensett, Albert Bierstadt, George Inness, Thomas Cole, Frederick Edwin Church, Winslow Homer, and others.

GEORGIA O'KEEFFE
Georgia O'Keeffe

Georgia O'Keeffe chose to write this book—the first about her life and work—*herself.* Reissued in reasonably priced paperback format, it contains all the paintings and text of the original edition and is manufactured to high standards in consultation with the artist. "An exceptional book. . . . The color photos are among the best this writer has seen in a book about a modern painter"—Hilton Kramer, *The New York Times Book Review.*

THE NECESSITY OF ART: A MARXIST APPROACH
Ernst Fischer

This is a Marxist interpretation of the whole history of artistic achievement—from cave painting to Picasso. Originally published in 1959 in Germany, it has gone on to become one of the most influential books on art since World War II. Whoever reads it—no matter what his political persuasion—will have to recognize that Marxism illuminates many profound truths about art that no other theory could yield.